PAINTING ANIMALS
IN WATERCOLOUR

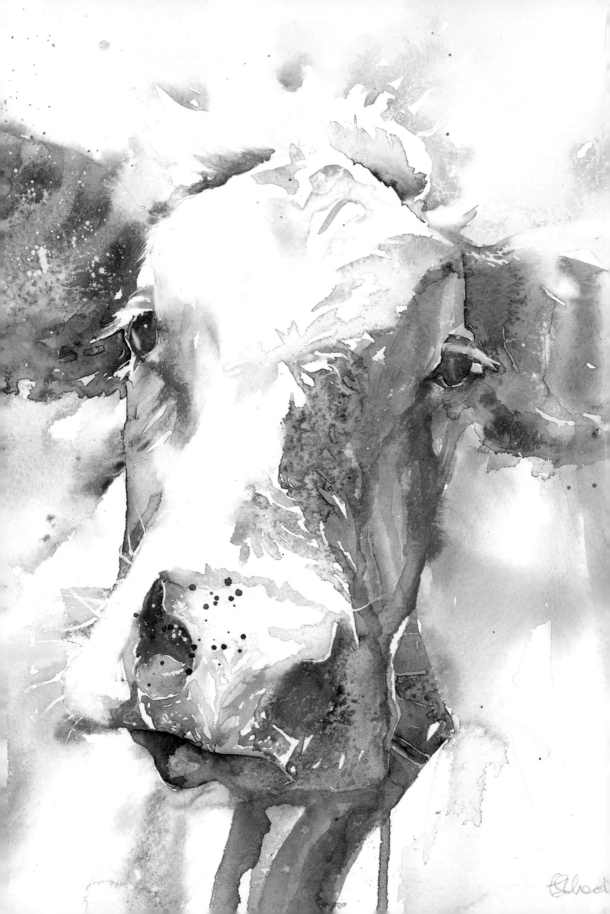

PAINTING ANIMALS IN WATERCOLOUR

Liz Chaderton

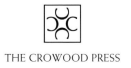

THE CROWOOD PRESS

First published in 2020 by
The Crowood Press Ltd
Ramsbury, Marlborough
Wiltshire SN8 2HR

enquiries@crowood.com
www.crowood.com

This impression 2022

British Library Cataloguing-in-Publication Data
A catalogue record for this book is available from the British Library.

ISBN 978 1 78500 787 3

Frontispiece

The Cow with the Zebra Ear, original size 35×35cm, watercolour on paper.

Dedication
Thank you to everyone at Crowood for bringing this book to life. Grateful thanks to all my students at classes and workshops who have been guinea pigs – I always learn so much from them. I thank my family for their patience and tolerance as my art spreads from the studio into every room of the house. Finally, thank you to the beautiful animals (especially @bassethound_sofie) who have posed and bring me such joy.

Typeset by Kelly-Anne Levey
Printed and bound in India by Parksons Graphics

CONTENTS

INTRODUCTION

The joy of capturing animals in artwork (and why you should draw from life)

Since the time when early Homo sapiens drew bison and wild horses on the walls of their caves, we seem compelled to capture the amazing variety of animal life and integrate their images into both our functional and decorative objects. What is so striking is that the animals in even these earliest depictions, though many thousands of years old, have a life and essence that leaps off the rocks and down the centuries at us.

Many artists still feel the same compulsion to draw animals today, and the challenge remains how to breathe life into our paintings and make the animals jump off the paper. For me, the question is how to capture the essence of the beast. Painting every hair or feather might capture a likeness, but a few well-chosen lines or brushstrokes of paint will capture the character and soul of the animal. It is the latter approach that we will explore here.

What is my motivation to paint animals?

OPPOSITE PAGE: *Catch Me While You Can.*
Crop of dodo painting in ink, watercolour and metal leaf on panel. Original size 46×55cm.

We are living through what scientists call the sixth mass extinction in Earth's history. Human overconsumption is causing a crisis not just in the climate but for wildlife. Common and rare species are being lost, and we are to blame. Even the most humble farmyard sheep or domestic cat is a creature of incredible beauty and complexity. By discovering and capturing that beauty, and sharing it with others, I hope to prompt a more caring attitude to the animals with whom we share this planet and, in turn, the environment we all rely on.

It is inevitable that when you start drawing or painting animals you rely on photography; however, there comes a time when you will want to inject more life and movement into your work and you therefore need to study animals from life. The purpose of this book is to help you with the leap from simply capturing a likeness to really looking at and seeing the animal as it is.

The feasibility of a safari or venturing into the rainforest is low for most of us, but we may have pets, see wildlife in our parks or live within a relatively short distance of a zoo. While it can be daunting to work outside and in public, the benefits are immense. This book aims to be a really practical guide on where to go, what to take and how to overcome nerves. Rather than to be a glossy reference book, it has been written (I hope) in a way that you will feel you are painting or drawing along with me. I want to see its pages thumbed and splashed with paint.

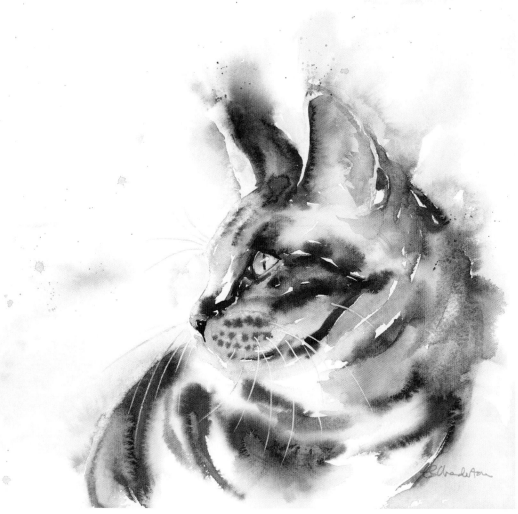

Tabby, 35×45cm, watercolour on paper. A domestic moggy is as amazing as a wild tiger when you start really looking.

These sketches aren't an end in themselves, and you might think that they are pretty rough, to be honest. Once you have studied and sketched your animal, you will want to develop your sketches into a more finished painting back in the studio, so the second half of this book gives prompts and ideas to help you do so.

I chose to use water-based media. You might think of watercolour paintings as delicate and ethereal – they can be, but they can also be vivid and passionate. You might think of them as subtle and hidden away behind glass – they can live exposed in the spotlight on canvas or panel. You might question their versatility, but watercolours can mix with other media and hold their own. I don't think of watercolour and ink as poor cousins of oil paint or a pale imitation of acrylics. Watercolour is a powerful medium in its own right. I hope to convert you to my way of thinking.

Drawing and painting are skills to be learnt and practised. Just as you would not expect to be able to run a marathon without a preceding training regime, please do not be disheartened if your first sketches or paintings do not turn out as you wish. You need to train your eye and exercise your hand. Practice really will make perfect, and do keep your early pieces, to see how far you have travelled.

So, I would like this book to help you to see the extraordinary in the animals you encounter and also to explore the versatility of watercolour in capturing your observations of, and emotional responses to, animals.

Above all, if this book encourages you to pick up a pencil, pen or brush and try to capture the fauna around us, I shall feel it has achieved its goal.

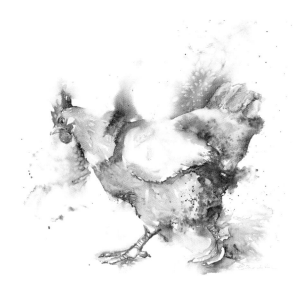

On a Mission, 45x35cm, watercolour on paper.

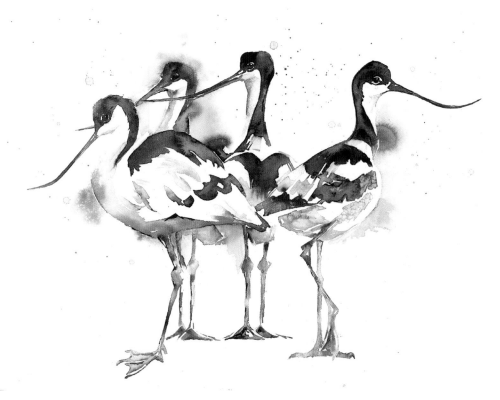

We Are Family, 45x33cm, watercolour on paper. Painted after a visit to Birdland in Bourton-on-the-water to capture that lovely swoop of their bill and their blue legs.

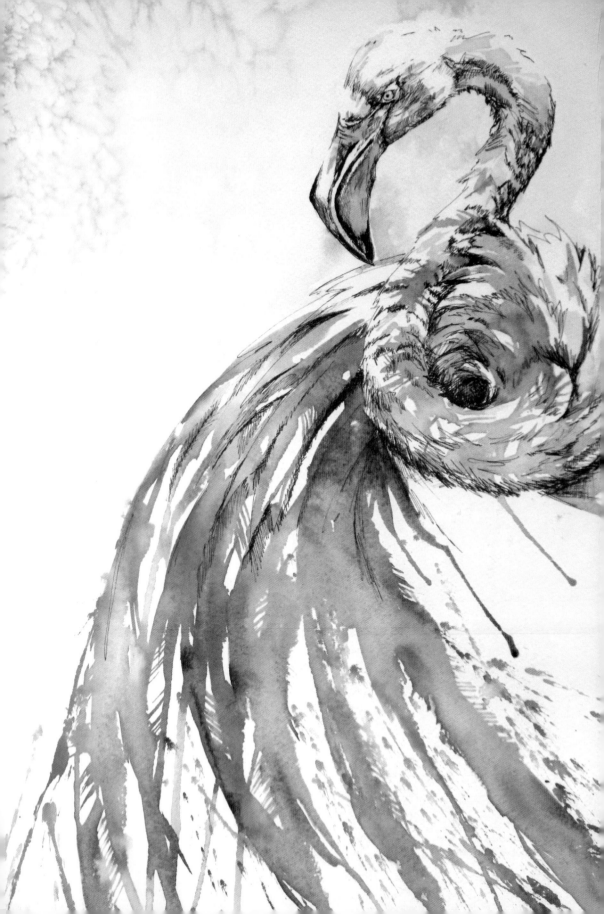

DRAWING TECHNIQUES

Draw what you see, not what you know

Deciding to learn to draw and paint can be daunting. We procrastinate and sabotage our efforts by waiting until we have the perfect pencil and a pristine sketchbook or have collected the long list of recommended supplies. The good news is that all you really need is something to make a mark and a surface to put that mark on. You can start to train your eye to truly see by using a ballpoint pen and a piece of photocopier paper. So let's jump straight into techniques and worry about materials later.

There are two main challenges when you start to draw. The first is training our hands and eyes to work together in a coordinated way. This is usually a simple issue of practice; do it enough and you will get better. The second challenge may be trickier, as it involves unlearning our experience so that we see reality and not what we expect to see. We need to learn to 'forget' what we are drawing and instead focus on the truth of the subject.

But first, to try to stop you turning ahead to the painting chapters, let's consider why we should bother honing our drawing skills.

OPPOSITE PAGE: *In a Twist*, 35×55cm, pen and watercolour on paper.

Why draw from life?

You may be thinking that it would be so much easier to draw from a photograph than having to worry about your subject stretching and moving or your having to pack up your supplies and head off into a field or to the zoo.

Drawing forces you to study your subject more closely, allowing you to absorb its shape, form, character and movement unconsciously as you work.

The freshness and honesty obtained by drawing from a living creature is hard to imitate. If your subject may run off without a moment's notice, you know you have to work quickly. What's more, you soon work out what is crucial about that animal. Is every stripe of the cat important as it pounces on the mouse? No, of course not. However, the curve of the cat's spine and the coiled energy in its back legs are. Working from life will make you take immediate decisions about what to put in and to leave out.

Drawing from a living subject can breathe life back into your work. So, even if you are an experienced artist, knowing that your subject may not stay around will help you to react faster and to improve your visual memory. Drawing anything in situ uses more than just sight; it uses all of your senses. Such sketching is incredibly rewarding. When you look at your sketchbook later, you will remember more about the whole experience, and an incomplete sketch will be richer than even the best photo.

Beyond everything, such drawing should be fun. You may get frustrated but, even if your drawings are incomplete and far from perfect, the very

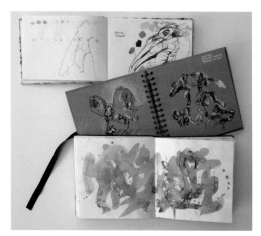

Your subject might not be around for long, so get the most important information down while you can.

fact that you have observed the animal featured in a sketch will have taught you a huge amount. That connection and knowledge will shine through subsequent work completed back in the studio.

Life is short, but art is long

It takes time! The phrase 'Life is short, but art is long', rather than meaning that art goes on forever, means 'There is so much art to learn and so little time to learn it in'.

There is a Chinese story about an emperor who told an artist to paint a cockerel for him. After a year, the emperor was fed up of waiting and demanded to know where his picture was. The artist brought out paint and paper and painted the most wonderful picture in five minutes flat. The emperor was furious at being kept waiting for something that took such a short time, until the (presumably terrified) artist showed the emperor around their studio, full of paper covered in drawings. It had taken a year to learn how to paint a perfect five-minute cockerel.

Therefore, remember that you will need to put in the time and effort to gain skills and

TIPS

- Look at your subject far more than you look at your paper.
- Try to draw as if you are seeing the animal for the first time.
- Observe for 90 per cent of the time; draw for the rest of it.
- Identify overall shapes and lines. Try to think of the subject not as a living thing but as a combination of three-dimensional shapes.
- Start with big shapes then work down to detail.
- Start with faint lines then add weight and detail.
- Be brave – it's only a piece of paper!
- Draw quickly, and use your energy to capture the animal's energy.
- Fill your page.
- If practical, draw big. It's hard to be expressive on a postage stamp.
- Use photos for reference only for detail and texture.

confidence. Keep your early drawings or paintings and, when discouraged, look back and see how far you have come.

Different drawing approaches

Described here are three different approaches to freeing up your drawing technique. You may find one to be more suitable for drawing certain animals or for your own personal style, but do try them all several times before rejecting or accepting each one.

Continuous-line drawing

What and why?

The basic idea is that you do not take your drawing implement off of the paper's surface while you draw. It trains your eye to move smoothly around the subject. It is also perfect for quickly becoming familiar with the quirks of the animal that you are studying.

How?

Select a drawing medium that gives a constant line. Now, let your eye move flowingly around the subject – both its outline and its internal features – and look for contours. All the while, let the hand holding your drawing medium follow your eye. If you jump to a different part of the animal, do the same with your hand, keeping your pen, pencil or other drawing instrument on the paper all the time. You may repeat lines and end up with lines running across empty space – both are fine.

Should you find that your drawings are still tentative and tight, try continuous-line drawing with your non-dominant hand. What you lose in finesse you should gain in expression.

You can further train your hand–eye coordination by doing blind continuous-line drawing – in other words, you don't look at your paper as you draw. You may end up with some very strange and Picasso-esque results, but they may also be charming.

Benefits

This is a fantastic way to start a drawing session, as it forces you not to take yourself too seriously, it also familiarizes you with the subject and ensures that your brain doesn't let you skip over large portions.

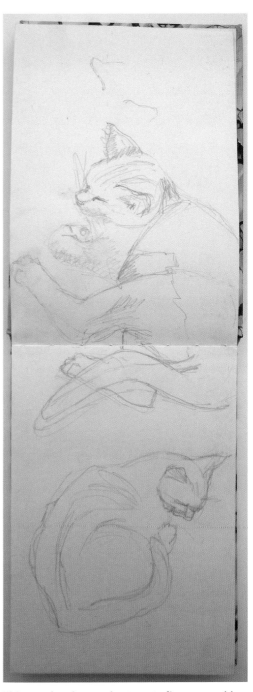

This cat sketch must be twenty-five years old, yet I remember where I was when I did it. Drawing from life engages all of your senses and your memory, regardless of the quality of the sketch.

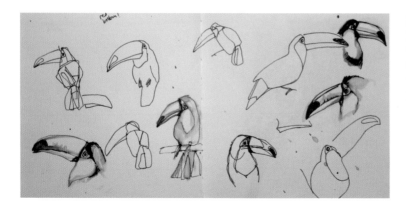

Using continuous line lets you spend more time looking at a moving subject. This toucan did not want to be drawn.

Gesture drawing

What and why?
The aim is to draw what you see, as you see it, in a variety of expressive marks. Gesture drawing allows you to rapidly record what you see and with purpose. This tends to work better on larger pieces of paper. Aim to hold your drawing implement at the end of its shaft to encourage free and expressive mark-making.

How?
It is important to look at your subject at least as much as you look at the paper. Imagine that you are describing the object with your hands while you talk to someone who doesn't speak the same language as you. Those hand gestures are very much like the ones you make when gesture drawing. It is simply a quick sketch in which your hand follows your eye.

By attempting to capture the spirit of the animal through a series of flowing contour lines and rapidly sketched shadows, the result is an essence drawing. Gesture drawing is a loose form of sketching that attempts to capture your subject's basic form and to express its movement.

Benefits
The making of the marks is quick and deliberate. You look at the subject and try to sum it up with a few marks, as you might describe it in a few words. Because you don't have much time, each mark should say something significant about the subject.

Drawing by identifying shapes

Why and what?
This method relies on identifying the basic shapes that the animal is made up of. Look for keyshapes that either contain the animal (external shapes) or are contained within it (internal shapes). By drawing these shapes and then developing smaller shapes within them, you create the subject.

How?
At its simplest, you can identify flat, two-dimensional shapes: perhaps the head is a circle, the muzzle is a square and a haunch is an oval. Put these shapes together in appropriate sizes and positions and then join them together and develop more flowing lines to capture the animal's form.

Alternatively, you might look for the shape that an animal fits within. An elephant seen head on fits within a coffin shape – flat across the top of its head, coming out to two points at the widest part of its ears and tapering down on both sides to the feet on the ground. In three dimensions, you may be able to see that the animal fits into a cube or a cylinder.

If you become a fan of this method, I highly recommend that you study T*he Field Guide to Drawing & Sketching Animals* by Tim Pond.

This method can be overused as a shortcut to drawing, almost to be learnt by rote; for example, a duck might be drawn as an oval with a smaller one perched at the front for its head. Care needs to be taken that you observe the animal rather than making the assumption that it fits with the shorthand you have learnt.

Benefits

This method is particularly useful when drawing a foreshortened subject. If you identify that the animal is basically a cuboid with a leg at each corner then drawing it in perspective becomes easier.

Putting the techniques together

Realistically, as you develop your drawing skills, you will probably use a little of each of these methods in one sketch. You might identify a few shapes and roughly sketch them in using a more gestural approach and then check your work by using angles and lines, before finessing the contours, while observing the animal rather than looking at your paper.

However, by practising each method in its pure form, you will be able to find the strength and weakness of each approach and start to work out which feels natural to you or what type of mark-making suits each animal.

Making notes

It is useful to jot down incidental observations while you sketch. All things that you note are useful, regardless of how good or bad your sketches are. Some artists take this further, with their sketchbooks becoming in effect a

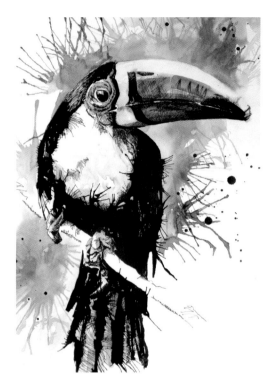

The effort of studying an animal pays off when you come to paint it.

visual diary. See Chapter 2 for more information about journaling, if this is a direction that you wish to go in.

Don't be afraid to make notes to prompt your memory. A note might be of an impression or an overheard snippet of conversation, perhaps about the animal or its environment, or be a colour prompt.

Any questions that occur to you as you sketch are worth noting down. You can research the things in question at your leisure, and the answers may lead you in an interesting direction.

If you add measurements and quantities to your notes, you are starting to collect data as well as visual information. Combining drawing, text and data may take you down a more scientific path, but science does not have to be at odds with art.

A restless, hairy subject called out for gesture drawing.

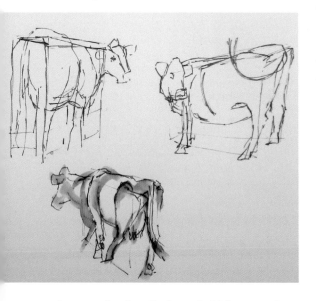

Cows can be described as cuboid, because they fit into a three-dimensional rectangle.

Order of working

- Start with the spine – look for the line that runs from the tip of the nose or beak to the tip of the tail.
- It is sometimes more accurate to judge the distance from the animal's belly to the ground rather than to judge the length of the animal's legs.
- Rather than drawing the shape and angles of the legs, draw the spaces between them; this will accurately give you the shape, separation and angles of the limbs.

Other considerations

Measuring

When drawing a still life or portrait, using a careful measuring-and-comparison technique is the norm. With a living breathing subject, using such a considered approach is a luxury; however, perhaps if the subject is snoozing, you may wish to do so.

Identify a unit present within the subject that you are drawing – it could be the width of the head. Holding your pencil straight in front of you, with your arm out straight and one eye closed, mark the length of this unit, as measured from the tip of your pencil, by placing your thumb on the pencil's shaft. Now, with your arm still locked, compare the marked length on the pencil to other parts of the subject. On your paper, use the same proportions to accurately represent the objects you are seeing. Keeping your arm locked means that the pencil is always at the same distance from your eye and will make your measuring more accurate. You do not need to draw at life-size – it is the proportions that are key. If the cat's body is five times the width of its head, on your page, it does not matter whether you draw the head as 2cm or 5cm, as long as the body is either 10cm or 25cm, respectively.

Timed drawing

For this approach, using whichever drawing technique you like, you will need plenty of paper and a timer. For the first attempts, you have only 30 seconds to complete the drawings of your subject. Repeat. Increase the drawing time to one minute, but keep the drawing approach as when you had half of the time. Be bold and forget about making mistakes. Repeat. Now, increase the drawing time again. You will notice your lines becoming more confident in appearance. Look at what you are drawing as much as the drawing itself, and do not stop moving your hand when you look up at the subject.

Negative space

Negative space is the area around the main subject of the image: the shapes and spaces that define the subject and various elements within your drawing. Choose an object or scene with interesting shapes within it – for example, I think that leaves on a plant or tree are interesting. Identify what appears to be the main area of negative space around the object and then try to draw this; forget about the subject of the image – concentrate purely on the shapes and angles that make up this image.

Creating a sense of distance

Relative size
Animals closer to you will be larger than those far away. Seems obvious, doesn't it? If you are drawing a group of animals, varying their sizes will create a sense of distance.

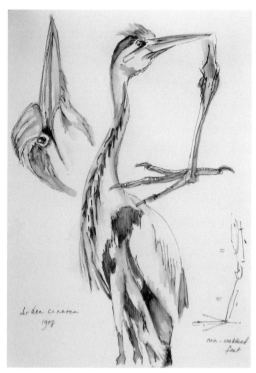

Should your drawing go off the page as with this heron sketch, made in a museum, whatever you do, don't try to squash it in, as you will distort the proportions. Either continue the part that won't fit elsewhere on the page or stick an extension of paper into your sketchbook.

Detail
Managing the detail you put into a sketch can also say something about how near or far the subject is from you. Close to you, you will be able to see every feather or strand of fur. Further away, what you can see and interpret will be about shape. By varying the detail you capture in a group sketch, you will create a sense of distance and focus. Areas of high contrast will catch one's attention and bring that area closer to the viewer.

Weight of line
Using a heavier line will bring the animal closer to the viewer or will at least give that impression. A finer line will appear further away.

A typical sketchbook page, with notes and impressions. It is not a thing of beauty but contains information to prompt my memory.

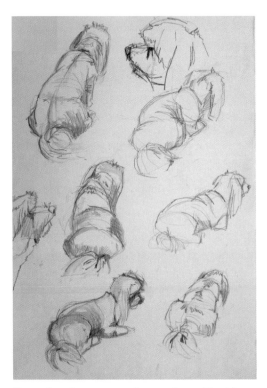

Capturing the essence of a moving subject is hard, there is no denying it. Use a large sheet, filling it with sketches. When the subject moves, start again to sketch, and, if it returns to the original pose, simply take up where you left off.

Hard and soft lines

Lines closer to the view will be hard and in focus; those further away will be softer, out of focus and possibly lost.

Moving animals

The problem with animals is that they have the nasty habit of moving. While it is wise to start your drawing journey with large, slow-moving animals, most people aspire to capturing the essence of faster animals at some point. Of course, photos really help to freeze the action, but the danger is that the photo freezes a millisecond of unnatural movement rather than capturing something that is characteristic of the beast.

- Spend time watching the animal, and try and work out the components of its movement.
- Familiarity makes it easier.
- Identify whether a position is held a little longer, indicating that it is characteristic of the animal's movement, and look for repetition.
- Even the slightest and most incomplete drawing is helpful. You will have absorbed more of the character than you realize by making a sketch.
- Body shape will change as the animal moves.
- Use the direction of your marks to indicate movement of the animal.
- Implied movement can be represented, for example, by careful depiction of the shape of the spine.

Checking accuracy

As we have already covered, your brain is wired to see what it thinks is there or what you intended to draw. We need to trick our brains into seeing what is really there and not what we

meant to put down on paper. There are several simple ways to do this.

- Turning your drawing upside down.
- Using a mirror to reverse the image.
- Looking from a distance.
- Simply walking away and giving your eyes and brain five minutes' rest: fresh eyes are more honest.
- Asking a trusted and honest companion for their opinion – it is far easier to spot other people's mistakes than your own.
- Using diagonal, vertical and horizontal lines to see where lines cross on the actual object and then whether they do so on your drawing.
- Taking a photo – errors seem more obvious on a screen.

Use the measuring and negative-space techniques already described to check the relative position of features. Hold a straight object vertically or horizontally in front of your drawing, and check

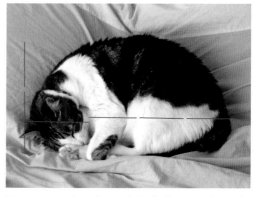

You can see that the cat's body is approximately three times as long as its head and about two measurements deep. The negative space is the crumpled sheet in this case.

what lies on that line. Is the animal's nose above the front foot? Is the nose higher or lower than the curve of the spine, and so on? If something looks a bit off on your drawing, check the angles between major features, such as between the head and body. This method will quickly reveal any errors.

JUST DO IT

- No time spent drawing is time wasted.
- Worry about style later.
- Drawing starts at home – sleeping domestic animals are the ideal first subject, followed by animals in wild-life documentaries on TV, with the aid of the pause button.
- Choose slow-moving, simple, large subjects – an old Labrador will be easier to draw than a terrier puppy; an elephant will be better than a gazelle.
- Choose your view – a side-view sil-houette will be easier than struggling with foreshortening.
- There is safety in numbers – start with a flock or herd.
- Label and date each drawing.

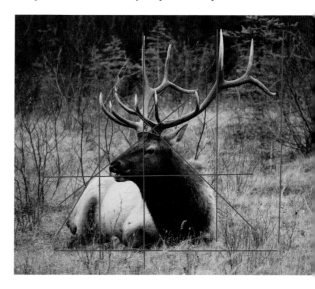

The lines indicate the angles and levels that I would subconsciously check to ensure accuracy. The height of the antlers is roughly the same as the distance of the head to the ground. The angle of the nose is the reverse of the angle of the neck, and so on.

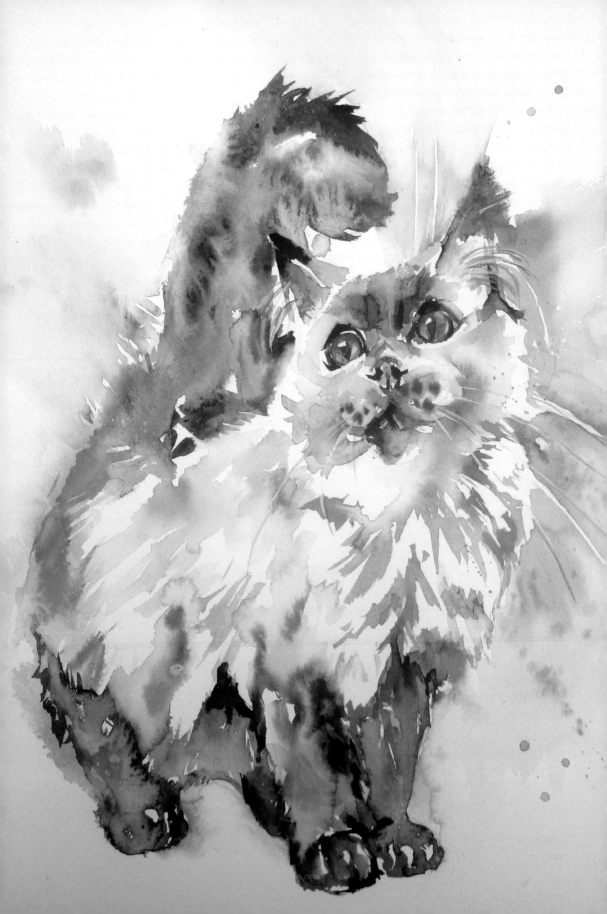

WHAT YOU NEED AND WHERE TO GO

Initial considerations

It's worth stopping for a second and thinking about what your animal studies are intended for. This book is written assuming that you will want to turn these studies into finished paintings; however, that may not be the case. Perhaps you wish to keep a visual diary or develop an art journal. Perhaps your bent is more scientific and you wish to keep a nature journal.

WHY DRAW ANIMALS?

Ask yourself why you want to draw animals, because the reason impacts your media choice. There are many different reasons and motivations for drawing.

- As a fun way of enjoying drawing for the sake of drawing, with no expectations and no fear of failure.
- To train your visual memory.
- To create a book that is a work of art in its own right.
- To explore and document your relationship with the animal kingdom.
- To collect data and evidence for scientific study.
- To collect information for development later in a studio setting.
- As training for further exploration – perhaps before going on a holiday of a lifetime.

OPPOSITE PAGE: *Ragdoll Cat*, **35×45cm, watercolour on paper.**

All these options are equally valid, but your intension will impact the materials you choose to use, and, of course, there is a large crossover.

Whatever you call your output – art journal, sketchbook or visual diary – in the end, the important thing is that you are looking at, recording and interpreting the world. You just need to get some marks on paper. Drawing is a muscle that needs regular exercise.

What to look for in your supplies

We have already noted that the danger of a long supply list is that it puts up a barrier to actually starting to draw. Nevertheless, the danger of not having one is that you may acquire or already have materials that thwart rather than support your efforts. Take a quick trip to any art shop, and you will be dazzled with the array of goods on offer; yet, many artists have bags full of 'stuff' and an empty sketchbook.

My guiding principle is to find the sweet spot between cost and quality. Materials that are a little bit better or do a little bit more than you would have expected should find a place in your art bag or cupboard.

Of course, which materials you want is driven by the purpose of your sketching. The suggestions given here are to support observational drawing with the end goal being to go on to

Sketchbook or journal? Determining what you want your drawings to be for will guide you to choose the right drawing surface and format as well as which materials to use.

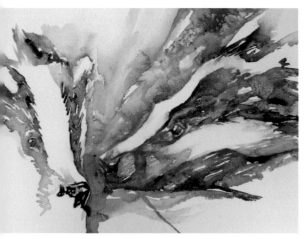

***Badgers*, 35×45cm, watercolour on paper. Are your sketches destined to become finished paintings? This finished artwork was inspired by our nightly visitors at a holiday cottage in Dorset.**

develop finished artwork. Should you decide that development of an artist's journal is your goal, your materials list will differ. Additional watercolour materials, other studio supplies and more technique-specific materials are covered in Chapters 5, 8 and 9.

As well as addressing the cost–performance sweet spot, if you are sketching away from home, you will need to consider that you will be carrying your supplies all day. Keeping the weight down is an obvious necessity, so versatility is key. If you have left something at home, improvise, and perhaps discover a new way of working. All you really need is something to draw with and on.

What to sketch on

Let's consider the subject of when a sketchbook stops being a sketchbook and becomes a journal or a visual diary.

Sketchbooks

A sketchbook is used for collecting information, developing ideas and recording inspiration. It might be used to work out what you think and feel about a subject or to plan and develop a more finished piece. They tend to be private and personal, as they record your impressions and thoughts in a raw, unfinished way.

On the whole, a sketchbook will be visual, but the artist may choose to supplement sketches with written notes. These might be general observations or questions about the animal or its character or personality or be colour notes.

Again, a generalization, but dry media work best for use in sketchbooks, though plenty of artists do like to use watercolour as an addition to ink, pen and pencil.

The lovely thing is that, given that a sketch is known to be rough and unfinished, this means that you do not have to aim for perfection in your sketchbook. It is a place to explore your ideas and observations: a bit like talking to yourself, but in a visual way.

Sketchbooks come in a bewildering array of sizes and paper types, so consider the end point. If you want to produce a sketchbook as an end in itself, one with quality watercolour paper within may be the best choice. If the sketchbook is a working document, one with paper that is good enough to take a light wash is sufficient. You probably won't want to take an easel or drawing board, but a hardback book lends support. While a larger book gives you space to be expressive, it may be obtrusive and unwieldy and is harder to hold while drawing standing up.

My preference is a hardback, bound, square sketchbook. It is impossible to work across a wire spiral, but, if you wish to do an elongated sketch, working across the gap where the sketchbook folds is straightforward. My favourite (currently) is a Seawhite's hardback that is 20cm square. Also, a heavy cartridge paper will take a light wash and is pretty versatile.

Concertina

A concertina sketchbook is one where a long strip of paper is folded multiple times to create the individual pages. They are easy to make yourself, which means that you are in control of the paper quality and size. They can have a nasty habit of unfolding on you in high winds, so use a bulldog clip will keep yours under control. They are ideal for documenting over time, as they lend themselves to a visual narrative. Should you be travelling on holiday, visiting one specific place or studying one species, this might be the ideal choice.

Tinted

Coloured paper looks very effective with black marks. There are some inexpensive kraft paper books available, intended for scrapbooking. They are usually robust enough to take a light wash, and the brown paper makes a good foil for pastel work. If working with watercolours, it would be sensible to add gouache to your kit or to select more-opaque colours. A white pen, white pastel or white charcoal pencil will be needed to obtain the highlights.

Art journals

Journaling is having quite a moment. Artwork in a journal tends to be a completed project in its own right. Pages, whether a one- or a two-page spread, are intended as finished pieces. There is often an intention to share your output. Ideas are fully realized, or at least there is no intention to take them further into a larger project. If a sketchbook is work in progress, an art journal is the final destination. It seems that the more you can throw at a page the better. Whereas a sketchbook is about recording your impression and ordering your thoughts towards a final outcome, an art journal seems to be therapy in paper form. Mixed media and writing are often key, for example, by incorporating quotes and sayings. The content is not just from observation. There are many excellent online resources and books to stimulate you, should you decide to go down the journaling route.

What to sketch with

With so many sketching media to choose from – pencil, brush, pen, charcoal – it's easy to be overwhelmed.

Graphite pencil

This is the obvious choice. However, graphite pencils do not bring a lot to the party. A dark, soft pencil, while expressive and quick to use, can smudge easily in your sketchbook. If you

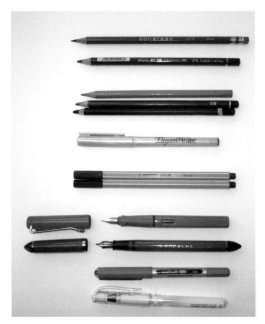

From the top: Col-Erase pencil; Polychromos pencil; graphite pencils of HB to 6B hardness; Elegant Writer pen; Stabilo Point 88 pens in black and sepia; fountain pen; fude-nib pen; rollerball pigment-ink pen; white gel pen.

choose to add watercolour, the graphite can dissolve in the wash and muddy your work. The advantages are that these pencils are cheap and readily available. If you choose to use pencils, consider taking a few of different hardnesses, from HB to 4B.

Coloured pencil

If you enjoy sketching with a pencil then using a blue one may be a far better option. If you have used only cheap colouring pencils designed for children's use, it is a wonderful revelation when you pick up an artist-quality pencil for the first time. My first Polychromos pencil wiped away all my preconceptions.

Non-photo blue pencils were used by animators, before the arrival of digital animation. The

idea is that the pale phthalo blue is not easily picked up by cameras or photocopiers so does not show up in finished artwork that is photographed, scanned or copied. If you use a blue pencil to sketch with, you will find it just visually blends away when you work in other media over the top of the initial sketch.

John Muir Laws, the nature journalist, suggests using an erasable non-photo blue pencil to lay in the basic shapes of the animal being drawn. Once basic proportions or the posture has been captured, graphite or watercolour can be used over this drawing.

Though you can get erasable pencils such as Prismacolor Copy-Not Col-Erase non-photo blue, if you keep your lines light, you will find that they do not distract in the way that a graphite mark does and therefore do not need to be erased.

The Prismacolor Col-Erase non-photo blue pencil is good, whereas you may find that other brands make darker marks. If you struggle to find these pencils, a Polychromos or a pencil of a similar mid blue is a fantastic addition to your toolbox, especially if you intend to add a wash of colour. The downside is that some pencils contain wax, which can act as a resist to water.

Charcoal

Charcoal is a wonderfully expressive medium, with its ability to achieve broad strokes and detail; however, it is very messy and not ideal for working on location. You may use charcoal pencils, but then you lose the ability to use the side of the charcoal to get rapid coverage. If you sharpen such pencils with a knife rather than a sharpener, you can still have the side of the charcoal available for making broader, heavier marks.

Pen

The temptation with pencil is to be tentative and to erase lines. Pens encourage the creation of bolder, flowing lines. Given that you are unlikely to have time to be tentative when sketching animals from life, pen is my preferred tool. You simply have to add in the right line if you drew the wrong one first, and this can give a great sense of movement.

Dip pens are a disaster waiting to happen when on location (but I might just be clumsy!), so fountain pens or pigment liners in thicknesses suitable for the size of paper being used are the way to go. If the ink is waterproof, you can add a wash of colour afterwards.

Pens with a rollerball nib have a more pleasing feel to work with than those with a fibre tip. They glide over the surface of the paper, engaging your sense of touch as you work. Both rollerball and fibre-tip pens produce lines that lack character, so you will have to work to inject energy into your marks.

The Stabilo point 88 pen is fabulous. The ink is not waterproof, so you can do your drawing and then use a water brush to add water and introduce tone. The black and sepia pens are the most versatile.

Beware of using alcohol-ink pens, as the marks that you make with them will bleed through the pages of your sketchbook.

Fountain pen

A calligraphy pen or perhaps a Japanese fude-nib pen can add a variety of weights to your line. Normal fountain-pen ink is not waterproof, though it is available in a wide variety of colours. Quink ink splits beautifully with water but is not lightfast. This is rarely an issue in a sketchbook. If using waterproof ink in a fountain pen, ensure that you flush it out should the pen be out of use for a while. If the ink dries within the pen, you may never get the pen working again. Depending on the fineness of the pen's mechanism, some inks may block the nib.

Black is the most versatile colour for sketching. To date, Platinum Carbon ink, various registrar inks, including Koh-i-Noor document ink, and Daler-Rowney Calli ink have worked well in a LAMY safari fountain pen. The exact water resistance may also be affected by your paper choice. It is best to experiment ahead of a sketching trip.

If you are working on a tinted ground, you need a white pen. The marks made by the Uni-ball Signo pen are pretty opaque, as are those made by the Sakura Gelly Roll pen. Posca markers are also very useful in white or in cream (which is not quite as stark).

Other materials and equipment

Colour

My strong advice is to work in monochrome while you learn. This allows you to concentrate on drawing and observation. But, realistically, you will want to start adding colour to your sketches at some point. When you are ready, watercolour applied over penwork is the classic combination. Small watercolour-pan tins are available and very portable.

The smallest and lightest palette yet devised is made by scribbling dense patches of watercolour pencil on to a scrap of heavy watercolour paper. Using a water brush, you can add touches of colour to your work from this tiny palette. Note that using watercolour pencils to sketch with in the hope of later activating the lines with water is rarely successful. The lines are not expressive or satisfying.

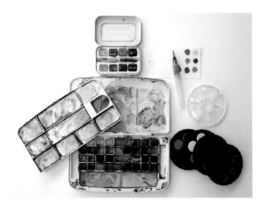

Portable watercolour paints come in all shapes and sizes.

The lightest-weight palette available, made from dense scribbles of watercolour pencils that are activated with a water brush.

Pastel pencils also are an interesting option, particularly on a toned paper. The issue will be smudging, so use of fixative is advisable. They mix well with charcoal.

Water brushes

While the brush element of these tools will in no way compare to the performance of a water-colour brush, given that water is contained in the barrel, their convenience is fantastic. Look for brushes with a valve to stop the colour being sucked back into the reservoir, and make sure that your brush doesn't leak. The brush tip can be cleaned on a tissue or cloth between the use of different colours.

Erasers

Don't take an eraser! Each line made helps you learn; don't erase your learning log.

Materials for outside sketching (en plein air work)

Comfort is everything. It is hard to sketch if your legs ache and you can't find the right tool for the job. Have a checklist tucked into your art bag, but ask yourself what you can leave out rather than thinking of what you can put in.

- A folding stool is very useful, as benches never seem to be in the right place. Just be

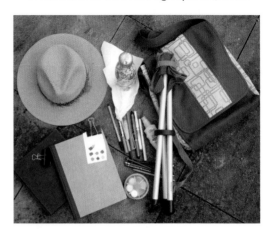

Anything in your en plein air kit has to earn its place. Think more of what you can leave out rather than of what you can take.

aware that you need to carry it, and you may be seated too low to get a good view. Many museums have stools for loan.

- Bulldog clips are often required to stop your pages turning in a breeze.
- A camera is handy to take further reference shots, but only as a backup.
- A bag in needed to put your supplies (and sandwiches) in. A bag with a cross-body strap is easier to access than is a rucksack. A messenger or computer bag is ideal, as they are padded and have plenty of pockets.

Clothing and comfort for outside sketching

In winter, think about layers. Warm wrists make for warm fingers, comfy feet are vital, and a cosy scarf stops the chills. In summer, a brimmed hat is better than sunglasses to protect your eyes. You may be so engrossed that you don't realize you are burning, so put on plenty of lotion! Whatever the time of year, you will get so caught up in your work that you forget to drink and eat, so be nice to yourself and take regular breaks.

Where to look for animal encounters

This book aims to present to you the necessary skills, materials and confidence to go out and about to sketch animals either in their natural habitats or in artificial settings such as zoos and museums, but it is sensible not to overlook the animals closest to us. Finding the extraordinary in the everyday is one of the joys of art.

Your own pet, or a friend's, will be an obvious starting point, though whether the animal will cooperate is entirely up to them.

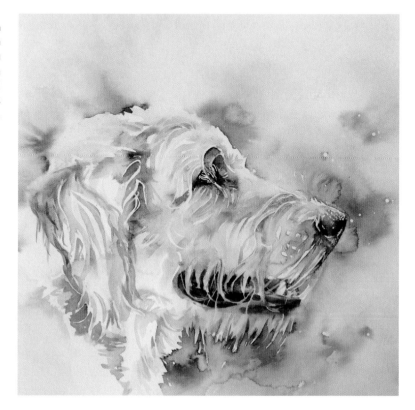

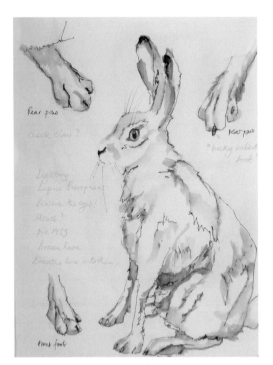

Even local museums have small taxidermy collections – though they may be quite sad. A stuffed hare let me study its feet in Reading Museum.

At home, with pets

Whether your own or those of a friend, pets will likely be your first subjects. Dogs and cats spend a good amount of time sleeping and are therefore ideal subjects for honing your drawing skills. Many people also keep chickens or more exotic animals, so do use your friends' pets and livestock to build your confidence.

On television

Documentaries will offer not only moving subjects but also multiple viewpoints of the same animal. Unfortunately, the demands of the audience mean that the pace will be rapid – no one will watch a lion doze for half an hour on TV, whereas one might in a safari park. The pause button is your friend. This is a good opportunity to practise timed drawings.

Museums

Often even local museums have a small taxidermy section. Whatever your thoughts are on such collections, they offer the chance both to study an animal in depth and to get used to sketching in a public place without being embarrassed. A weekday in a provincial museum is likely to be quiet. In real life, you are unlikely to be able to study the details of hooves or noses, for example: they will be too far away or hidden by foliage. A museum collection will let you really look closely at these features.

George Stubbs is famous for his study of animal anatomy, including suspending a dead horse in his studio so that he could study its musculature and skeleton. While such dedication to a deep study of anatomy is not necessary, some knowledge of the workings of the skeleton and muscles can certainly help if you have a puzzle while sketching. Many museums have a few skeletons, allowing you to see which way joints bend. While developing the character of our subjects, we are also trying to be anatomically correct.

Museums offer a good introduction to drawing from 'life', but just be aware that there are some poor examples of taxidermy out there. If a sample is Victorian, it may have deteriorated or been poorly executed in the first place. Colours may have faded, and the underlying skeleton will not be present. Eyes are often simply glass marbles, so don't take too much note of them. Lighting in a museum setting is often low to protect exhibits from fading, so you may need to take a torch if you really need to examine close-up detail.

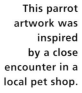

This parrot artwork was inspired by a close encounter in a local pet shop.

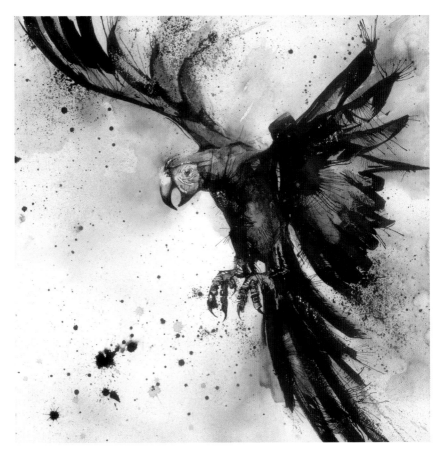

Farm settings

What could be nicer than a country stroll, with your sketchbook in your pocket, to capture the likeness a few cows, sheep or donkeys? The downside is that the animals that you wish to sketch will inevitably be on the other side of the field and hidden behind a thorny hedge. Take care not to stray off footpaths in your search for the ideal subject.

Consider children's farm parks for easier visual access to your subject. Many farm shops have a few animals nearby as part of their marketing strategy. If in doubt about anything during your visit, please ask, and remember that farms are working environments.

Pet shops

You would need to ask permission, but potentially pet shops may be a good environment in which to see and sketch a variety of small animals or even a parrot or two, up close.

Parks and nature reserves

Geese, swans and ducks will commonly be present and used to humans, so, if you go armed with a bag of crumbs, you should have a ready supply of subjects, whether in a dedicated nature reserve, at your local country park or by a river. (However, note that the feeding of wild birds is prohibited at some nature reserves, private parks and public places.)

Zoos, wildlife parks, aquaria and falconry centres

My personal rule is not to paint animals that I am not familiar with, so, if you are like me and want to extend your repertoire, zoos and wildlife parks are an obvious port of call. Many people have strong objections to zoos on the grounds of animal cruelty and ethics. If we had the right policies towards the environment, we probably would not need zoos. It has been said, however, that captive animals are ambassadors for their cousins in the wild. Furthermore, many zoos and wildlife parks play an important role in conservation and protection.

PETA (People for the Ethical Treatment of Animals) estimate that more than three-quarters of British zoos fail to meet minimum animal-welfare standards, so you need to be sure that you are visiting ones that do. If the cages are small and bare, you may get a good view of the animal, but you need to ask yourself pointed ethical questions.

Animal behaviour in zoos and wildlife parks is bound to be different from that in the wild. Animals are potentially fatter, lazier and in better condition than their wild cousins. At worst, they may show repetitive behaviour as a sign of distress. Remember that, although good zoos try to create enriching environments for their animals, these are captive creatures.

The owls and birds of prey at falconry centres are used to being handled and to crowds, so they are shockproof and more likely to be in clear view for longer than are birds in the wild. Similarly, the fish and animals at aquaria are used to being observed and, again, may be easier to look at for extended periods of time.

When to go sketching

If there is a particular animal that you want to draw, check when it is active. For example, sloths might stay in the canopy for most of the day and come down towards the ground only late in the afternoon. If you are going to a venue such as a museum, zoo or park, avoid school holidays if you don't want to be trampled by children. Winter may be quieter. Animals from warmer climes may stay immobile and close to their heat lamps, so you may or may not get a better view. Standing outside sketching in the drizzle can be rather depressing. Fingerless gloves are a must!

Many zoos give a discount if you buy a ticket online in advance. Check out the savings available, and spend what you save on a new sketchbook.

Outdoor sketching in the wild

You have to have the right temperament to get up at 4am to go into a cold, wet hide to try to spot an elusive animal. I do not have this patience. If you want to pursue this type of study, you will need specialist equipment, such as binoculars and a tripod. Please refer to Jackie Garner's excellent *The Wildlife Artist's Handbook*.

First steps in en plein air work

Congratulations for taking your first steps to sketching in public. It can be nerve-racking, but you will find that people will be interested, not critical. Non-drawers will wish they could draw, and artists will understand your bravery.

Ease yourself in and start with something relatively easy. Big animals tend to move more slowly than small ones. Herds or flocks will give you more to observe than solitary animals. If you are at a zoo or wildlife park, there will be fewer people around unpopular animals. Remember that, for a museum setting, taxidermy doesn't move.

Choose a flock or herd of slow-moving animals as your first subject. Flamingos are ideal as they tend to repeat a limited number of poses.

Select a group of animals for your first drawing. In a zoo, flamingos or penguins are good, as are shoals of fish. At a farm, cows are more docile than sheep.

Before you start, spend time observing. How do the animals move? What actions are repeated? Is there a pattern of movement and rhythm that you can discern? So, if you are looking at flamingos, you might see them stretching their neck up, they might drink with an S-shaped neck, and they might preen or tuck their head under a wing for a snooze. Some might stand on one leg; some on two.

Now, taking an open, double page, start with depicting one of those identified actions. When the animal moves, start on another pose. When the animal goes back to the original activity, add a bit more information to your first picture. In this way, you will be working on multiple pictures across a double spread at any one time, adding information to each action sketch as the animal moves. The advantage of viewing a group is that, if one animal stops doing what you are drawing, another is likely to still be doing the same thing. You can quickly build up a record of repeated behaviours in this way.

Now, change medium, and fill in the spaces of your spread with other identified and repeated actions. Try to capture the animal from the side, front and back. Maybe add a detail of the beak, the eye or the feet.

In general, start with big shapes, develop smaller shapes, and add tone and then finally details. Fill the pages with pictures from many angles until you have a general understanding of the form and movement of the animal.

Do take notes if anything strikes you, as it will help you to remember the experience. It might be the light, the environment or an overheard snippet of conversation. You are trying to capture a rich reference source, so that when you look at your sketches even months later you will be transported back to the experience.

Divide your time up, so that you don't spend all day making myriad sketches of one animal only. Your aim will be both to flex your drawing muscles and to capture plenty of information that you can develop later on into finished artwork.

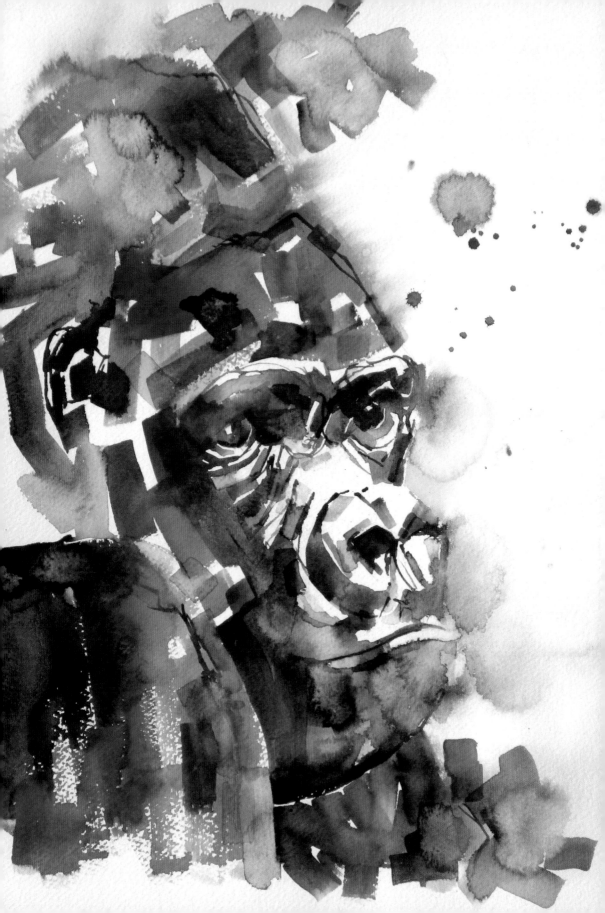

USING COLOUR AND PHOTOGRAPHY

If you think about it, adding colour to your sketches and using photographs to supplement your sketching observations are simply two different ways of capturing more information. Neither should become a substitute for the process of observing and drawing, but both are exceptionally useful.

Colour

Using monochrome drawing media will really help you to hone your observation, drawing and mark-making skills, but of course the colour of animals is part of their fascination and joy. So before long you are likely to be fed up with using only a black pen or a grey pencil.

The danger of moving to colour is that, if you are spending time finding the right colour out of, say, twenty possibilities, you are not looking at the animal. Sketching from life is all about observation, and you should endeavour to spend more time looking at the subject than looking at your paper or art materials.

On the other hand, a big advantage of colour is that you can incorporate negative painting into your work; you are capturing additional information, and, let's face it, colour is just fun.

Being realistic, you could not be expected to stick to black pen on white paper for too long, so let's explore some of the options.

OPPOSITE PAGE: *Dignity*, 35×45cm, watercolour on paper.

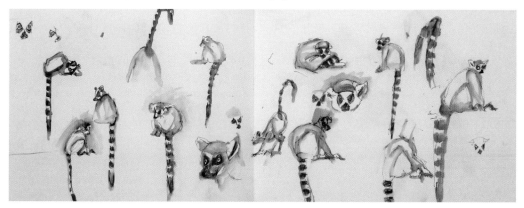

Monochrome sketches have a charm of their own, so do not rush to colour. Depicted here are lemurs at London Zoo; you can get up close in their enclosure.

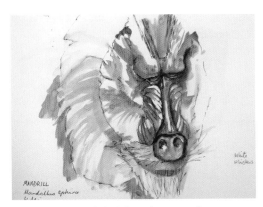

A mandrill sketch in ink and watercolour.

CONSIDERATIONS

When selecting the means to add colour to your field sketches, you need to be practical. You need to think about the following factors.

- Weight – if you are carrying your supplies all day, you will rapidly decide that less is more.
- Requirement for water – water weighs a lot and gets spilt. If you are painting in a zoo, a curious toddler is likely to kick over the water pot that you momentarily placed on the floor or – worse – take a swig from it.
- Speed of use – mixing up just the right colour takes time, and, if you are trying to capture a moving animal, time is not on your side.
- Accuracy – if you are going to rely on your sketches for future work and you like to stay true to nature, you will want to be accurate.

Same picture, different colour

Now consider how important colour accuracy is to you. If tone defines the form of the animal, colour brings emotion to the piece. It may be a cold, grey day, but, if you are full of excitement and buzz at being at the zoo, maybe your colours should better reflect this feeling than the absolute colour of the animal. A purple giraffe might communicate your awe at its height better than a browny-yellow one. In this regard, the choice is entirely yours. Only if you are illustrating a scientific zoology book must you stick to the 'real' colours.

It is important to realize how much colour varies with changing light conditions. Local colour is the natural colour of an object unmodified by adding unrealistic light or shadow or any other distortion. The colour that the eye observes is altered by lighting conditions such as time of day or the influences of the surrounding environment. So, a flamingo will look pink (its local colour) in neutral lighting but might be perceived as orange under a warm afternoon sun or more lilac in cold winter shade.

Colour options

Working on a toned ground

It is amazing what a difference the introduction of a toned paper can make. The usual choice is to select a midtone colour and then work into it with a light and a dark tone (say, with a white and a black pen), which means you have a three-tone drawing.

Brown kraft paper is a good option, as it is robust enough to take a light wash. Small spiral-bound scrapbooks can be obtained for just a few pounds and are perfect for outdoor sketching. Larger versions are readily available, if you need space to be more expressive.

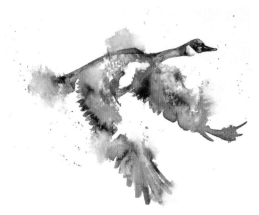

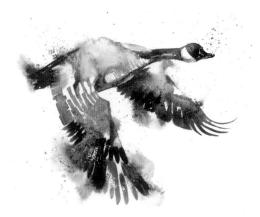

A Canada goose on its way to our local country park.

Same picture, different colour – is colour accuracy important to you, or are you happy for different colours to be part of the story?

You might also consider using pastel pads, which are available as coloured sheets, and Strathmore produce Toned Tan and Toned Gray journals that are acid-free. The Strathmore Mixed Media paper is heavy enough to take significant washes and do finished watercolour work upon (184lb/300gsm).

Using these grounds with a fine-liner or rollerball pen with waterproof pigment ink for the darkest tone and an opaque white pen (uni-ball Signo is a good option) to highlight and bring work to life is a simple option.

You can use watercolour on toned grounds, but the colour of the ground will significantly alter the perceived colour of the watercolour. You will also find that coloured papers appear darker when wet, so you will need to account for this change while working, as the piece will appear different when dry.

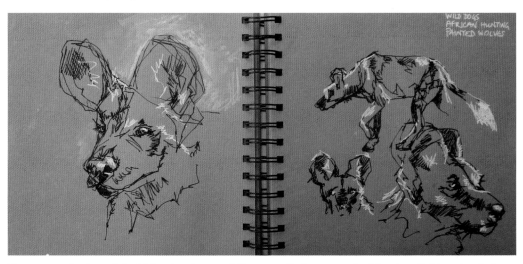

The pages of a toned sketchbook act as a midtone, so that you need add only a light and a dark.

Toning your sketchbook

Consider toning your sketchbook before you go out sketching. If you have leftover paint in your palette, why not tone and texture a page? When you are in the field, you can select a toned page that suits the subject you are sketching. Once you have sketched, you can then add further colour to define and clarify details of the subject, if necessary.

You could simply tone with a stain, such as diluted waterproof ink or an old tea bag. Stain has the added advantage of not lifting, should you

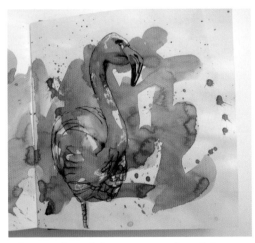

When you have leftover watercolour, it is a good idea to create interesting toned pages. Next time, you can choose a toned spread that suits your subject.

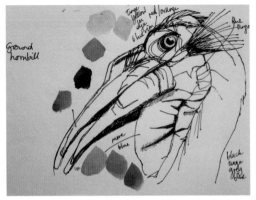

Noting down or adding colour swatches can be a simple way of capturing colour information.

later use a wet medium on top. Adding a stain to the page also has the advantage of relaxing you: many people find a white page terrifying!

Making colour notes

Rather than aiming to paint your entire study, it may be quicker to place colour notes around your drawing. A colour note is a swatch of colour that you might want to supplement with written notes. All these patches and notes may look messy on your page, but your sketchbook is a working tool, and to have too much information is better than not having enough. As you become more experienced with watercolour, you may wish to use the hue names of the watercolours to bring more nuance to your information; that is, rather than noting that a bird is blue, you might write 'Prussian blue with phthalo at the highlights'.

Pen and wash

If you have been sketching in waterproof ink, you can apply light washes of watercolour over your drawing. Generally, if you use your brush to make marks lying in the same direction as that of the fur or feathers of your subject, you will develop more-convincing volume. We will look at pen and wash in greater detail in Chapter 8.

Watercolour pencils

As noted before, sketching with watercolour pencils is not very satisfactory, but you could rapidly apply colour in areas of your sketch and then, when the animal has moved on, take a moment to blend the pencil with water from a water brush to build up tone and form.

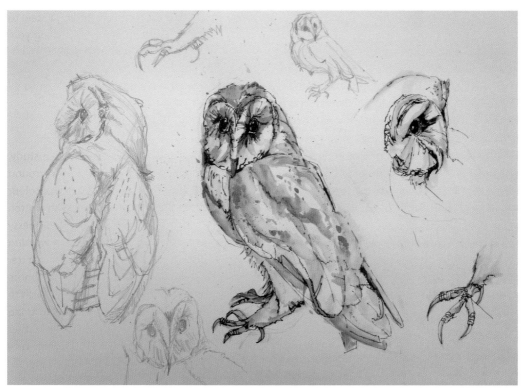

Pen and wash is the classic on-location means of capturing colour information. This A2-size study sheet was completed from a natural-history exhibit and inspired the pastel-and-watercolour piece in Chapter 9 (see the section 'Barn owl').

Neocolor crayons, pastel pencils and oil pastels

While all of these media can add colour to your sketches, do they add more bang for your buck and are they worthy of a place in the bag that you will need to carry all day?

Caran d'Ache Neocolor crayons have a high pigment concentration that results in bright, opaque colours, suitable for many techniques on dry or wet paper. They are softer than coloured pencils and denser than children's wax crayons, being extremely responsive to a wet brush. They lack subtlety and, given their opacity, will potentially mask details of your sketch.

Soft or oil pastels are good options for dry media to add colour to your wildlife sketches, should wet media be unavailable. They can be blended with a fingertip to be a dynamic and exciting addition to your sketch. You may need to take a can of fixative with you, to avoid your sketchbook becoming a smudgy mess. A workable fixative will allow you to add further marks, should you wish to adjust your sketch later (take a look at Ironlak fixative). Pastel pencils may be a less messy option, with the downside being that you cannot use the edge for making broad strokes of colour.

Coloured-ink pens

While black and sepia pens are invaluable for sketching, coloured pens do not have much versatility and therefore do not earn a place in my sketching kit.

Photography

Photographs never lie – or so goes the received wisdom. Though they may not lie, they certainly omit to tell the full truth. Photos have shortfalls, and, before you use them as a reference, it is as well to be aware of what these are. Let us not be sniffy: just about every artist uses photos at some point. The secret to using photos appropriately and successfully is to take steps to compensate for the shortfalls of photos as reference material. In the end, photos are not substitutes for your own eyes.

It is so easy to have tunnel vision and see the world through the small square of your view-finder or the screen of your phone. When you look back at these images, you may have no recollection of actually seeing the things that you have recorded. So, sketch and take colour notes before reaching for the camera; it is for backup rather than as a primary source. If and when you use photos, try to use your own rather than other people's. If you use someone else's photos, you aren't necessarily painting your own concepts, but copying.

Shortfalls of photographs

Realize that relying on photos can make for a flat, unconvincing painting.

Colour

The camera cannot see like the eye can when it comes to colour. Compare your photo-graph's colours with those of real life, actively decide what you want to do and then adjust accordingly. You can exaggerate and increase the saturation or adjust the colours back to those of nature.

Depth of field

An out-of-focus background might be desirable in a photo but does not leave you much choice or options when you are painting.

Shadows

Photographs kill shadows: whites are bleached out, and darks are pitch black. In real life, we don't see the world like that. In watercolour, you may wish to brighten the highlights, but you may also brighten shadows and introduce colour. You may find that a low-contrast photo gives you details in the dark as well as the light areas and allows you to choose how dark or light to go while painting.

Distortion

Odd angles and fisheye effects may look super in photos but not in a painting. You may not even notice such distortions straight away. They tend to be obvious with architecture but per-haps not with animals. First, be aware of these distortions; second, remove these distortions or expand upon them in the way you want to. If you like the look then exaggerate.

Capturing a moment in time

A single photo can capture only a brief moment in the life of an animal, and the posture and behaviour of the animal in that moment may not be remotely typical of that animal. Think of party photos with people's eyes closed and mouths gaping: animal photos may be the equivalent.

Focus

Auto-focus cameras often capture everything, even distant objects, in focus and make everything appear sharp even in areas where our eyes would never see so clearly. You need to decide what the focal point is and make that the only area in focus in your painting, while everything else can be rendered with softer edges and with less visible detail.

Distance and perspective

Photos make faraway things look quite sharp and minimize the effect of atmospheric perspective. For a more dramatic sense of depth in your painting, you may want to emphasize those changes, pushing the lightness, dullness and coolness of distant objects.

When photographs come into their own

Use a camera as a backup to sketches. Most animals are too impatient to make good models. Use sketches for recording the main aspects of the subject, and finish with making a snapshot for recording detail and colour. Photos can be used to check on the details of markings or parts of the anatomy you could not see when sketching. Referencing photos for details of markings and colour is fine, but always use your time with the animal to try to capture its essence.

Copyright

When photographic images are used merely as a starting point and you do not intend that the final image closely resembles the essential features of the source photographs, there is less likely to be a breach of copyright. The legal test will be to place the original and resulting images side by side, in order for a layman – that is, not an artist or someone trained in the arts – to judge whether it is obvious that the two are visually connected and whether the artwork is a partial copy. If they are several identifiable visual connections, a copyright breach would be likely.

For anything more than personal use, always seek permission before using an image created by someone else.

Tips for taking photographs

- Plan things in advance. If you have an idea for a painting, think about what photos are needed to support the execution of this painting and then take the necessary photos.
- Try using different camera angles and positions.
- Aim for photos with shading, depth and a good range of values.
- Do not use the flash function.
- Use natural light. If possible, get light falling at the side of the subject and avoid glaring sunlight, as the shadows will either be absent or too strong.
- Be aware of which direction the light is coming from when taking each photograph.
- Take lots!
- Make notes; if you see the subject just through the camera's lens, you are not using all your senses and will not remember as much about the subject and its surroundings.

Where to find useful photographic references

Personal photography will be best, as you will have actively composed the shot and be attracted to something in it in the first place. There are no copyright issues with personal photos either.

However, it is not always possible to use only personal photos, so, for checking detail, books and magazines are wonderful. The BBC Wildlife magazine is both educational and a wonderful visual library. Newspapers often carry excellent animal photography, but the print quality may be poor. Remember that, just because a photo has appeared in print, it does not mean that it is copyright-free. Calendars may have excellent animal photography, especially the charity ones.

Turning to the web, there are some excellent royalty-free websites such as Pixabay, Unsplash and StockSnap. There are other photo websites, such as Flickr, on which some photos are available under free licences. The site Paint My Photo hosts an active artist community that encourages the use of photography featured on the site. There are also numerous Facebook groups such as Photos for Artists through which photos may be obtained.

It is your responsibility to check the terms of use and whether attribution is required. Consider that the photographer may have spent thousands on expensive kit and got out at 4am for three days in a row to get the perfect shot, so do not infringe their rights.

Reference and inspiration can come from anywhere, whether it be a national newspaper, calendar, leaflet, birthday card or magazine. However, you must be aware of and respect copyright.

Working from photographs

Choose actively

Try to make the experience of working from photos as close to working from life as possible. Perhaps do a warm-up continuous-line drawing. Identify shapes within and without the subject; look for angles. Decide what you like in the photo and what is important in its content and composition. Do not simply copy. Ask yourself what you want to say about this image. Just as when working from life, decide what you want to paint, where to crop your image, what to leave out, what to focus on and what is less important.

Check the lighting of your reference – where does it come from and, if you are combining multiple references, is it consistent? Pay attention to the lightest and darkest areas: can you still see details there? Choose a photo that shows more than the level of detail that you want to achieve. For a looser painting style, use lower-resolution photos. The lower resolution will make it impossible to see certain details, allowing simplification of shapes and resulting in the painting of only what is truly necessary to understand the subject.

Use multiple reference shots. Take many photos of your subject from different angles, varying distances and pointing your focus to areas with different lighting.

Edit

Free software will allow you to crop, draw, paste, change colours, change backgrounds, add and overlay extra images, change the light colour and deepen or lighten shadows and highlights. If you are struggling to identify tones, use editing software to make a black-and-white copy.

Add

If you copy a great photo, it will look flat and boring in paint unless you do something, you add something. You must ask yourself why you are bothering to paint this photo, and how your painting will be better than the photo.

Print

Some people say work from a screen, so that you can zoom in and perform other similar actions for your photo. I think this encourages slavish copying. Print your photo on to photograph paper, if possible, to gain as much nuance as possible. But remember, shadows and dark areas don't print well. Darks get darker and therefore lose detail. Also, having printed your photo, when your laptop or camera battery charge runs out, you are not stuck.

Compose

Crop the photo as needed, making the crop proportional to the size of your canvas. Use the photo mainly as a guide for your drawing, proportions and value relationships, but feel free to alter colours as best serves the painting.

Don't forget to squint! If you don't see it when squinting, don't paint it. This allows you to simplify and paint general to specific. Only at the very end, when it's the appropriate time to add the details, you can paint some of the details you see only when not squinting. Choose well. Most details are usually on your focal point.

Lighten shadows

A good rule of thumb is to lighten up the darks and darken the lights. Don't paint the shadows black, even if that's the way they appear in the photo. There is always some local colour even in the deepest shadow.

Put it away

In the end, your painting needs to stand by itself, so put the photo away: let your painting talk to you. Respond to your own picture, and make it work in its own right.

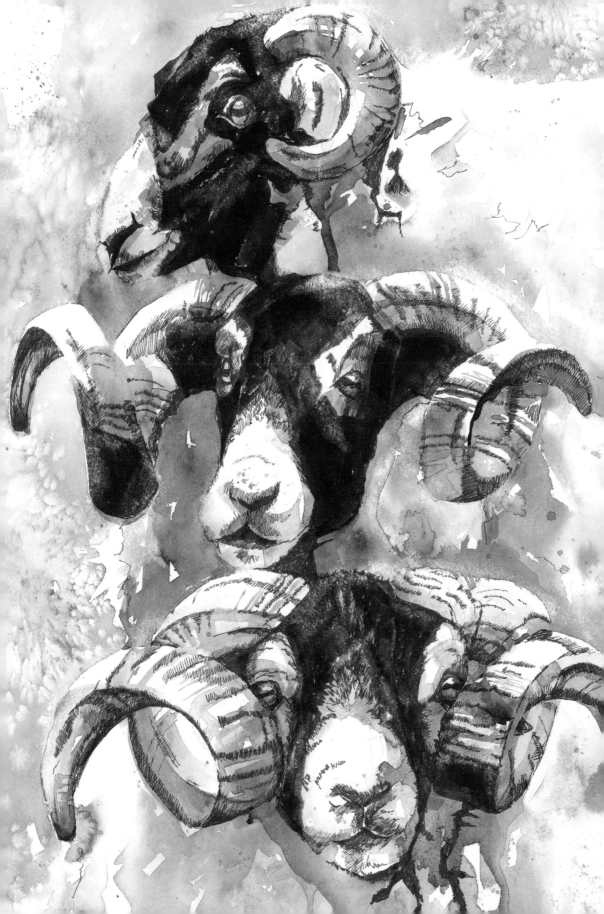

COMPOSITION AND DESIGN

Turning your sketches into paintings

Five or ten minutes of planning will save you hours of heartache. If you don't know where you want to get to, or have few ideas of the route, then the chances of arriving at your final destination and, indeed, even knowing you have arrived, are slim. The guidance is simple: know why you want to paint your subject, keep it simple, and have a plan.

Planning

- Study your subject – really get to know it.
- Know what you want to communicate.
- Collect reference material, primarily sketches and photos. See how other artists have painted the animal previously and aim to do something different.
- Create a few thumbnail sketches to determine the composition, format and size of your artwork.
- Select your colour palette.

OPPOSITE PAGE: *Baa Humbug*, 35×55cm, ink and watercolour on paper.

What have other artists done?

We are quite rightly taught not to copy, so you may have been surprised by the title of this paragraph. However, if you are about to paint a particular animal, it can be useful to research what other artists have done. An online search for the term 'watercolour' plus the animal's name will of course bring up thousands of images. The idea is to see what most artists paint and then work out how you can do something different. Far from plagiarism, this is 'uncopying'. You may be surprised that you start to spot who has used a particularly popular photo to base their work on. So, if you want to paint, say, a duck, and an internet search identifies lots of images of ducks standing on one foot, perhaps you would like to avoid repeating exactly that format and instead paint a duck looking over its shoulder. There is nothing wrong with painting what other people have done in the past, but you might find something unique to say by first exploring the obvious renditions of your subject.

The power of a thumbnail

Always try to do a thumbnail sketch before starting. This is not to be shown to anyone and is your working document. A thumbnail is probably 5–10cm in size and is a space to map out the best format, check on the way the light falls,

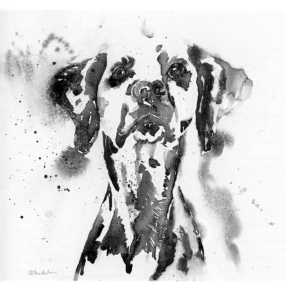

Always ask yourself why you want to paint a particular animal subject. The idea of a non-black-and-white Dalmatian made me laugh.

A thumbnail is your chance to explore possible compositions and to get an idea of where to start and what you are hoping to achieve. It is not meant to be beautiful but is a route map to guide you through your painting.

WHY DO YOU WANT TO PAINT THIS ANIMAL?

- Find the focus – what attracted you to this subject in the first place?
- Look for the main tones – consider lights, medium and darks. The area of greatest contrast will draw your eye, so put it at your painting's focus.
- Include only what is really needed, and use the art of suggestion. Try to say the most with the minimum input, and allow ambiguity.
- Paint something simple and well, rather than aim to paint something complicated and fail.
- Determine whether you need a background. If yes, plan for it, and don't add it on as an afterthought; if no, work outwards from the centre of focus.
- Simplify, and do not be a slave to accuracy.
- Use as few colours as possible – three should be enough, with six or seven being the absolute maximum (see the later section 'Colour selection' for more about planning colours).
- Mix darks from colours that are opposites on the colour wheel that you have used elsewhere in your painting.
- Don't use a colour in only one place.
- Feature a variety of edges – hard, soft, lost and found. They create interest and movement.
- Start with a large brush, and finish with a small one.
- Don't fiddle – finish too soon rather than too late.
- If something attractive is happening, consider stopping there.

identify areas to save for light tones and high-lights, and plan your order of working. It's worth creating a couple of options, so that you do not simply go for the most obvious rendition. So, as well as making a line drawing, it is good to map in your values or tones. In watercolour, you are essentially painting shadow and leaving light, so identifying these areas within your composition at the planning stage is crucial.

Format and size

The danger of having a pad of watercolour paper is that every painting turns out to be of the same size and format. You may alternate landscape and portrait orientation, but that is often as far as it goes.

Actively decide on the format that suits your idea – vertical, square or horizontal. Consider size, too; a miniature version of a composition will communicate something entirely different from an oversize version.

Do consider your surface as well. A rough handmade paper may add to your interpretation of your subject, whereas a smooth one may detract, or vice versa.

Composition

A pleasing composition takes planning and thought before your pencil or brush hits the paper. No matter how skilfully you paint, if the subject is plonked in the middle of the paper, it will be boring.

Though composition is much a matter of personal taste, the following sections present some guidelines, to help you to achieve effective compositions.

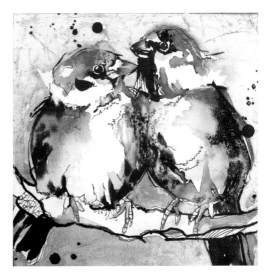

I have painted these sparrows as a 25cm square and as a 100cm version. The size makes a huge difference to what is communicated by each painting.

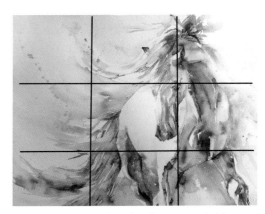

Your painting needs a focal point, and this will often be the animal's head on a full-body portrait, or its eye on a head-only painting. Aim to place the head, or eye, on an intersection of the third lines and to place other important features along the lines of the thirds. As you still have to be anatomically correct, you will often need to get the 'weight' of the painting in the right place.

Rule of thirds

This is a simplification of the golden mean. Essentially, it states that, whatever the format of your piece, if you divide both its horizontal and its vertical

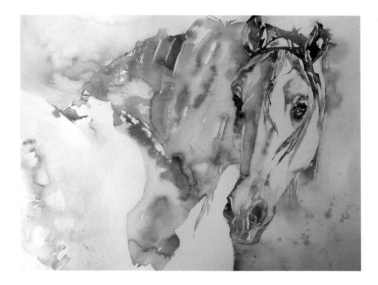

The point of this painting was to depict the lovely shadow of the horse's head, so simplification was crucial.

sides into three and imagine connecting lines running across the piece, so that you end up with nine equal sections, you should aim for a prominent feature of your composition to fall on an intersection of these third lines. There are four such intersections or 'power points', and you should select one for the placement of your painting's centre of interest.

Other key features should be arranged by taking the third lines into account, particularly by placing these elements on one of the third lines.

Remember that colour, contrast, sharp edges and detail will attract the eye. So, you will want to place the area of greatest contrast at your centre of interest, and you will want to avoid placing areas of high detail and contrast in the very middle of your painting.

Simplification

Form your overall design from a few big shapes. Large adjoining shapes work so much better than non-overlapping small shapes scattered all over the painting.

You need to link shapes to create a flow and link the light and dark areas together for rhythm, balance and movement.

Remember that threes work really well – include three areas of a colour, tone or texture, for example.

Negative and positive space

It is always worth observing the space around the subject. We call this the negative space. The subject is the positive space. Aim to make the negative space of your painting really varied and balanced. You may wish to emphasize and create interesting negative shapes in your composition. One way to do this is to have parts of the

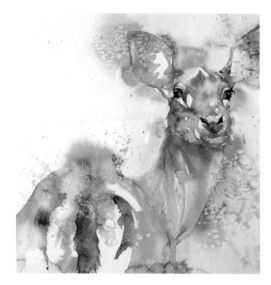

The free space around your animal is as important as the subject. Aim to have interesting negative space.

Ask yourself the following questions when you have come up with a composition.

- Is there a centre of interest? If the viewer doesn't have somewhere to focus on in the painting, they will feel lost.
- Does everything feel like it belongs together? Does anything look like an afterthought? You should aim for a unified whole.
- Does it make sense? Do different parts of your composition work together in proportion? Consider how things fit together and relate to each other in terms of scale.
- Does it feel balanced, with one side not being heavier than the other? Think of a see-saw – several small elements might balance a large one. If things are symmetrical, the painting may feel calm, or indeed boring. Asymmetrical composition might be more dynamic but should still be balanced.
- Does the eye move round the painting satisfactorily, and does it get stuck anywhere? Consider using leading lines to direct the viewer. They might be real lines, such as those of whiskers and fur, or implied lines of splatter and colour. If your eye gets stuck somewhere, how can you move it on? Diagonals, triangles and circles all help with movement.

- Is there a repetition of underlying shapes, colours or marks that can lend a pattern and rhythm to your composition? Try to avoid using something in only one place; instead, aim to repeat or echo that particular element elsewhere. This also helps with the unity of the piece. One droplet might look like a mistake, whereas three will look intentional.
- What is the contrast in the composition? High- and low-contrast paintings feel very different. You are trying to convey a mood, so use contrast to support your intention. Every painting needs a full range of tones, from light to dark, but their balance leads to a painting being of high or low contrast.
- Is there variety in the painting's marks, textures and edges? No variety will make for a boring painting, but with too much it will be jarring. Aim to give the eye somewhere to rest if you are putting in a lot of variety and contrast.

animal going off the edge of your paper or canvas. A quick rule of thumb is to make sure that each corner of your piece has a different format.

Detail

A common question is about the amount of detail to put into a piece. Do you want to see every feather or every whisker? If you are reading this book, the answer is probably no, because we are aiming to capture the essence of the creature being painted. But, it is personal preference as to quite how loose you go.

The human eye is wonderful and extrapolates so readily. If you have a small area of detail, we tend to assume that the rest is there. By placing detail at the centre of interest, it implies that much more detail is present. If you have identified what attracted you to painting the animal in the first place and what you want to communicate about it, this understanding will help guide you about how much detail to include and where.

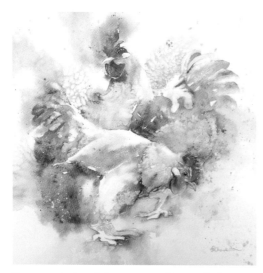

How much detail do you want? Every hair? Every feather? Or an overall impression?

Background

In my paintings, the animal is the star of the show. The intention is to keep the focus on the animal, and so the background is not overly important. My aim is to avoid painting a landscape that happens to have an animal in it. Another argument against including a literal or realistic background is that many wild animals have evolved to be camouflaged.

Your approach is a very personal one, but, whatever you decide, make sure that animal and environment are not too equal – you want to avoid your painting being neither fish nor fowl.

Having said that, painting an animal on a white background may be too stark. You may wish to hint at its habitat or introduce something that turns the piece from an accomplished sketch into a completed painting.

There are several approaches. Potentially, you could echo the colours of the animal in the background, but in a more subtle rendition. Alternatively, you could choose a complementary background that really showcases the creature. Exploit using pairs of complementary colours, for example, red and green, yellow and purple, and orange and blue. It will be worth making sure there are flecks of the complimentary colour within the animal, to link the two areas.

Simple does not mean boring. My favourite way to paint is to vary tone, add a little texture and bring out 'wafts' of colour by pulling the brush away from the animal (see Chapter 7).

Above all, think about your background before you start. If you get to the end and start wondering about what to do for the background, it is probably too late.

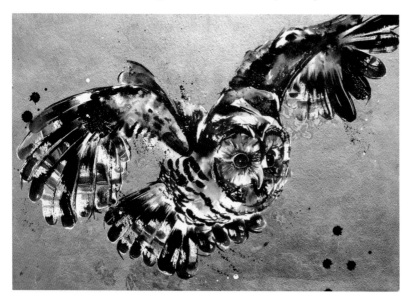

Background needs to be considered at the beginning and not the end of painting. I want my animals to be the centre of attention, so detail in the background is not important to me; however, the background still needs to be actively considered, and here I used copper leaf.

Order of working

Your thumbnail is also invaluable in helping you to plan the way you work as you paint. Rather than jumping around the paper, it is good to work in a flowing manner from the centre of interest outwards. There will be times when you will need to leave areas to dry, but you do want your painting to hang together coherently – dotting around will not achieve this end.

The transparency of watercolour dictates a few rules, so generally we work as follows.

* Light to dark.
* Background to foreground.

However, I find it useful to get some darks in early on, as these define your tonal range. For this tonal range, the white of the paper is your lightest tone; it is like the capital letter at the beginning of the sentence, with the darkest tone being the full stop. Your midtones simply fill in between the lights and darks.

Here is a general process.

1. Block in shapes, while saving whites (the area of greatest contrast will usually be at the centre of interest).
2. Add the darkest values.
3. Selectively glaze over areas of white space that you do not want to keep.
4. Add details and refine.
5. STOP!

Colour selection

There are potentially thousands of colours of paint that you could purchase, but using forty-eight colours in a painting will not make it more lively and beautiful; indeed, it is likely to have the opposite effect. Planning and limiting your colour use gives a huge advantage to you as the artist.

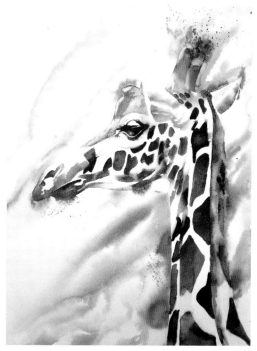

Only three colours were used in the painting of this giraffe.

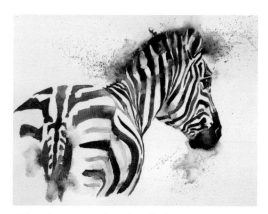

This zebra was painted with the same three colours as was the giraffe: alizarin crimson, quinacridone gold and French ultramarine. A simple palette can make for a more interesting painting.

Tones – the lights and darks – define the shape and volume of everything. This is why we have no problem recognizing the content of black-and-white photos. On the other hand, colour introduces emotion to a painting. Closely

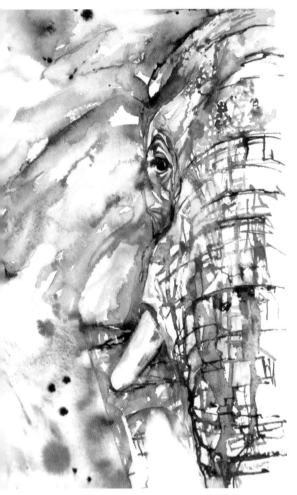

This elephant was painted in two colours that appear almost opposite each other on the colour wheel, giving a lively impression of grey.

it will be predominantly warm with a few areas of cool (perhaps in the shadows), or cool colours may dominate, with just a flash of warm somewhere.

Ask yourself what colours set the stage for the mood of the subject. Those colours should dominate the painting.

Get to know your colours

The more you get to know your pigments, the better you will be able to predict how they will behave and interact. Watercolour is an unpredictable medium, but you will be able to hazard a jolly good guess.

Tone

How dark is your colour when is at at full strength (that is, with just enough water to let it flow)? We lighten and darken watercolour by adding more or less water to it, not by adding white or black paint. Value swatches help you understand the required water-to-pigment ratio to achieve a particular tone or effect. Getting accustomed to making value swatches, especially for new watercolour additions to your paintbox, is a good idea. They are well worth the effort, as achieving an even step change in tone is harder than it looks.

Transparency

Watercolours are all transparent to a certain extent – it is a fundamental property of the medium, but it is just that some are more transparent than others. Such information should be either on the tube or in a paint chart, but, if you are not sure of the degree of transparency of a given watercolour, paint a milky wash of this colour over a waterproof dark line. If the paint veils the line, the paint is opaque; if the line is clearly visible, the paint is transparent; somewhere in between means that the paint is semi-transparent.

related colours may feel harmonious and calm. Warm colours may be uplifting and energetic. Cool colours may feel serene or depressing.

Remember, tone, not colour, is the really important thing. There is a lovely saying that 'Tone does all the work, and colour gets all the glory'. You can paint a grey elephant or a purple one; if you get the lights and darks in the right place, it will still feel real.

Just as we want to divide our painting into unequal shapes that are still in balance, we want to have a dominant temperature for our painting. Maybe

Testing the transparency of colours is straightforward. Here, you can see the opacity of both the cadmium red and lemon yellow.

The more you know about your colours, the harder they can work for you. How you can adjust your watercolours' tones with water and whether they are transparent are key bits of knowledge.

Granulation

This happens with denser inorganic pigments that have larger particles. These settle into the pores of the watercolour paper, giving a mottled effect. You can encourage this in your work by using plenty of water on rougher paper or by adding granulation medium. French ultramarine is notorious for granulating.

Staining and lifting

Does the colour sink into the paper so that no amount of wetting and rubbing will remove it totally, or does it sit on the surface, so that you can adjust the tone readily with a damp or wet brush? You may wish to select staining colours for initial layers and use more-opaque and easy-to-lift ones at the end of creating a painting.

A little colour theory

We were all taught at school that there are three primary colours and that, when mixed together, these make every other colour. The next logical question is why on earth have we got forty-eight colours in our paintbox and not just three?

Every paintbox needs to have a cool and a warm primary colour. This will allow you to mix both muted and clear secondary colours. While the colours across the colour wheel are called complementaries and will sing when placed alongside each other, they will neutralize each other to brown/grey when mixed.

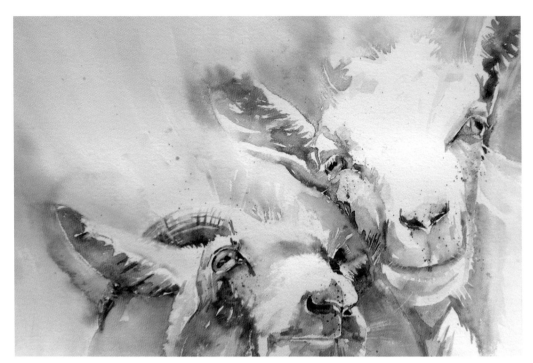

Learning to consider and leave areas of white is a crucial skill in watercolour painting. Small areas can be regained if lost, but nothing beats the sparkle of the untouched white paper.

Paint pigments are not pure primaries. Each has a bias; for example, lemon yellow is slightly green, so we say it is cool. Cadmium yellow is slightly orange, and we say it is warm. If you were to mix all three pure primaries, you would obtain black. In watercolour, you will get a brown/grey. So, it follows that, if you mix a yellow that has a tiny bit of red in it with a blue, you are actually mixing all three primaries. Mixing these will give you a slightly muted green. Hence, by having warm and cool versions of the primaries, you can mix muted or clear versions of the secondary colours – orange, green and purple.

Colours that appear opposite each other on the colour wheel are called complementary colours. Alongside each other they almost vibrate and set each other off. Mixed together, they subdue and grey each other. Getting to know and love your primaries is a joy.

Saving the white

If watercolour is transparent, it follows that we don't have white watercolour paint – transparent white is colourless, isn't it? So we have to introduce an opaque white, which might look at odds with the rest of our colours, or use the white of the paper as our white 'paint'. You quickly find that once you lose the white within your painting you struggle to get it back.

By far the easiest way to maintain white areas within a painting is to simply paint around the required white shapes. You need to be a little obsessive about this, as you can always get rid of white later on but will find it hard to get it back if painted over by accident. If the areas of white are too small or complicated to paint around then masking fluid may come to your rescue.

Masking fluid is a latex liquid that you apply to the paper. Once dry, you can paint over it. When you remove it, you will expose pristine paper. Such is the theory. In practice, you may find that the fluid adheres to the paper and also that the paint pools around it, so that you end up with an unpleasant hard edge. The secret is to apply it to dry paper and ensure it, in turn, is dry before painting over and beside it. Remove it as soon as possible, so that it does not weld itself to the paper's surface. Do not accept the white mark that you are given once the masking fluid has been removed; use a small damp brush to adjust your whites and soften the edges. The areas of white will then be far more natural.

As well as removable masking, you may use a permanent resist such as wax crayon or candle. If you use a white crayon, it will stop paint reaching the underlying paper. This is a dangerous game, as, if you put it in the wrong place on the paper, you are stuffed. However, it can produce interesting textural effects for the brave.

Adding a little gum arabic to your mix will make your paint easier to lift, or, if you put pure gum on your paper and let it dry, it will act almost like masking fluid and you will be able to regain your whites later on.

Regaining white

If you have lost a white or do not wish to use masking, you can use white gouache (an opaque form of watercolour), gel pen, ink or pastel to add final highlights.

The other option is to use a scalpel or craft knife to scratch out small areas of white or even sandpaper to lift some paint to result in multiple dappled white areas. With the sandpaper, you are effectively taking off the peaks of the paper. Your paper must be bone dry, and this is a kill-or-cure approach. You are damaging your paper, and there is no way back if you slip. On no account decide to paint over the damaged area, as the paint will sink into the paper and be darker. It should be the last thing that you do before signing your finished work.

Cropping

One of the advantages of working on paper is that a sharp pair of scissors can save a slightly dodgy composition. If you have a muddy mess to one side but the rest of the painting has merit, do not fear cutting off the offending part. If you wish you had more of a tilt to the animal's head, perhaps you can rotate your painting and then cut it to regain your right angles. Never be afraid to do a final crop; these small adjustments can make all the difference.

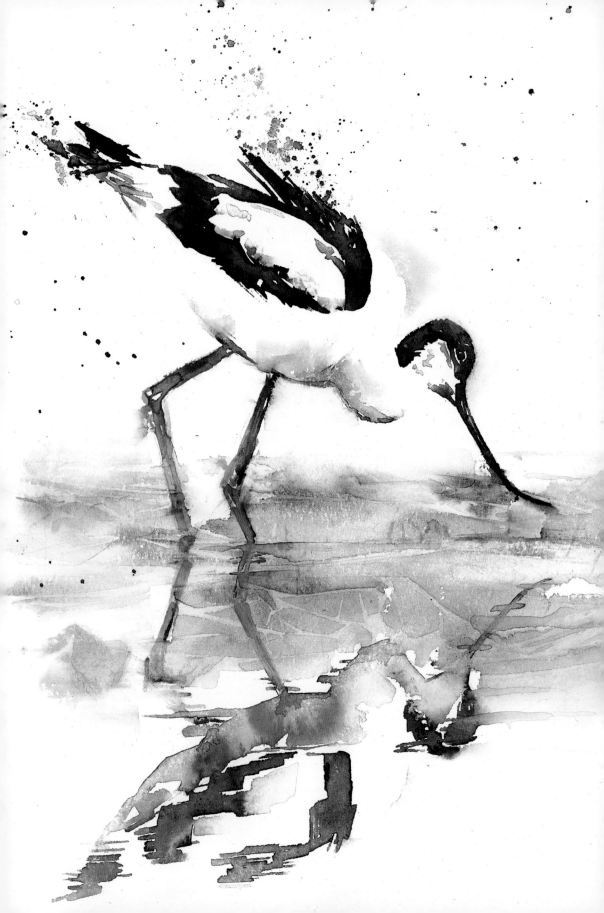

WORKING UP YOUR SKETCHES

Materials for use back in the studio

Portability and versatility are not such strong determinants of your supply list once you are back in your studio. However, I still look for my materials to hit the sweet spot of performing just a little bit better than you would expect for the price you have paid.

Paper

The surface is key to the success of watercolour painting. It has more of an impact than any other aspect of your supplies. You can paint a good picture with poor-quality paints on decent paper, but even the best pigments will struggle on nasty paper. As the surface is often left unpainted in places, it becomes an integral part of the work in a way that the canvas simply doesn't with the use of oils or acrylics.

There are three main types of paper – hot pressed, NOT and rough, as described in the following sections – and each surface will change the brushwork achievable with watercolour.

Note that different manufacturers' papers vary in their textures and in their other characteristics such as absorption.

OPPOSITE PAGE: *Avocet Reflection*, 35×45cm, watercolour on paper.

Paper comes in different weights, which is measured in pounds per ream or grams per square metre. The lightest paper is 90lb/195gsm, and paper weight goes up to 300lb/525gsm. The heavier the paper, the more expensive it will be per sheet.

The lightest-weight paper needs to be stretched before use for watercolour painting. However, anything that may prevent you from starting to paint is not worth it in my opinion. The trouble with stretching is that you must plan ahead. What happens if you stretched a piece of paper that is not of the size or format that you fancy when you come to use it? Far better to treat yourself to a heavier-weight paper that does not require stretching and can therefore be used without any planning ahead. Life is too short for stretching paper!

Should you experience mild cockling, that is, wrinkling or buckling of the paper's surface once wetted, then, to remove the waves in the paper, once the paper is dry, either gently iron the back of your painting or dampen it and weigh it down overnight.

Bockingford NOT paper, available at a minimum weight of 140lb/300gsm, is an excellent, reliable paper. It stands up to quite a lot of punishment without losing its sense of humour. Because it is not 100-per-cent cotton in material content, though is fully archival, it is an affordable option. It is made on a cylinder-mould machine, with its surface being created by use of natural woollen felts that give the paper a distinctive random texture. I use 140lb-weight paper for experiments and either 200lb- or 250lb-weight

Supplies for your studio work: a support board, mixing palette, ink, water containers, paint, masking fluid, masking tape, white gouache, hairdryer, pens, pencils, paper towel, spray bottle, craft knife and Magic Eraser.

paper for studio work. The larger you are planning to work and the more water you intend to use will increasingly point you in the direction of selecting a heavier-weight paper.

Hot pressed

Hot-pressed paper has a very smooth surface, which makes it ideal for detailed work. Its name comes from the manufacturing process, in which the paper is passed through hot rollers that effectively iron it flat.

NOT

This paper is so called because it is not hot pressed; thus, it retains some texture. There isn't so much texture to get in the way of detail, but it has enough to inject some character, and it holds on to more water, enabling you to work the paint longer.

Rough

Rough paper is rough in texture. The texture can be a wonderful addition to a painting and facilitates dry brushwork; however, it may also

become intrusive. Granulation effects will be more pronounced on a rough surface, and rough paper is often used for landscape work.

Colour

Watercolour paint is available in two qualities – student and artist – and in two forms – pans and tubes.

While pans are excellent to use for painting on the move, tubes are preferred for studio work, as it is quicker to mix vibrant, creamy washes of paint. Should you be using pans, it is worth spraying them with clean water while you set up. The water will sink into the surface of the paint, enabling the colour to be released without excessive scrubbing with your brush. Make sure that your pans are dry before storing them, otherwise you may run into mould issues, especially if you live in a warmer climate. You can replace or top up pans with tube colour, should you wish; the added paint will gradually dry, though those paints that contain honey may remain moist for a long time.

Student-quality watercolours are cheaper, as they contain less pigment or include pigments that are less expensive. Having said that, the student ranges from reputable manufacturers such as Winsor & Newton (Cotman) are a good option for those on a limited budget. And, because the student paints tend to be less lively on the paper, some artists actively choose to use them.

Different ranges can be mixed and matched. The same named colour may have a different appearance; for example, phthalo turquoise is visibly different between manufacturers, as is gamboge. To check on the identity and characteristics of a particular colour, you need to refer to the pigment code of the relevant manufacturer.

You do not need too many paints to start – around eight should do it. As detailed in Chapter 4, a basic palette will contain a cool and a warm version of red, blue and yellow. Add in burnt

sienna and raw umber, along with maybe a good purple or a sap green, and you should be able to mix pretty much any colour. If you want to paint flamingos, get a good pink! With time, you can treat yourself to new colours and build up your collection. However, just because you have fifty tubes in your paintbox does not mean that you should use them all. Aim to limit yourself to using six to eight, or fewer, in any one painting.

Brushes

With time, you will collect many brushes, but to start with a large round (size 14–16, coming to a good point), a smaller round (size 8), a rigger (size 2) and a small flat should be plenty.

The best watercolour brushes are made of sable, but, beyond the issue of expense, you may not wish to use animal products for your artwork. Synthetic fibres have come a long way in recent years. Look at the fluid-holding capacity of the brush and how it releases the loaded paint: you want a controlled release of watercolour. Also, look for a brush that is soft, so as not to disturb underlayers, and one that has good spring. If it is a round, it should return to a sharp point when wet and is tapped lightly on the side of your water pot.

Using small brushes encourages tight painting, so aim to use a brush that feels a little too big for the area you are painting.

Holding your brush

How you hold your brush makes a huge difference to the painted mark that you achieve with its use. If you hold the brush like you would a pencil, you will use only your fingers to move it, achieving control but lacking expression. Holding it lightly in the middle or even at the end of its shaft will mean that you use your whole arm and shoulder, resulting in less control of but more energy for your painting movements.

If you stand up to paint, you will engage your whole body. An overhand grip of the brush can add a different strength to your mark-making.

Don't forget that you have the point, the belly and the side of the brush at your disposal for mark-making. A few minutes spent experimenting with the variety of marks that a single brush can make will be time well spent. Aim for plenty of variety in each painting. Don't forget that you can use the handle, your fingers or a handy twig to make marks too; painting does not need to be done only with a brush.

Essential techniques

Tone

As we saw in Chapter 4, to lighten or darken your watercolour, you add more or less water. You do not add white paint, as this will immediately destroy the transparency of your colour, and it is the transparency of watercolour that makes it such a joy. Likewise, to darken a tone, do not add black, as this will alter the hue of the original paint. To deepen the tone, add further pigment. You will quickly realize that some colours, such as yellow, have quite a narrow tonal range, while others are far broader. This is crucial to understand if you want to start swapping colours around.

Washes

A wash is a simple layer of colour. Traditionally, watercolourists build depth of colour and the impression of volume by painting thin transparent layers over each other. Each layer must be fully dry before the application of the next layer, to avoid a lower layer being disturbed and muddied by the painting of a subsequent layer.

REMEMBER, REMEMBER, REMEMBER...

Watercolour is all about the water – it comes first in the name for a reason. If you are in control of the amount of water on your brush and the quantity of water on your paper, you are halfway to taming this unpredictable medium.

The second thing to remember is that watercolour is transparent. Each layer influences the ones above and below it. Even if you put a black layer over a yellow wash, the yellow will bias the black.

Less is more. You can always add more watercolour, but removing it is far harder. Once you have overworked a piece, getting back to fresh paint is very tough.

Do you remember that 'Tone does all the work, and colour gets all the glory'? If the lights and darks are in the right location and correct relative to each other in your painting, your subject will look real, and it really doesn't matter which colour of paint you use.

Watercolour dries lighter: it is up to 15-per-cent lighter dry than when wet. If you want bold colour, you need to increase the amount of pigment present in the wash.

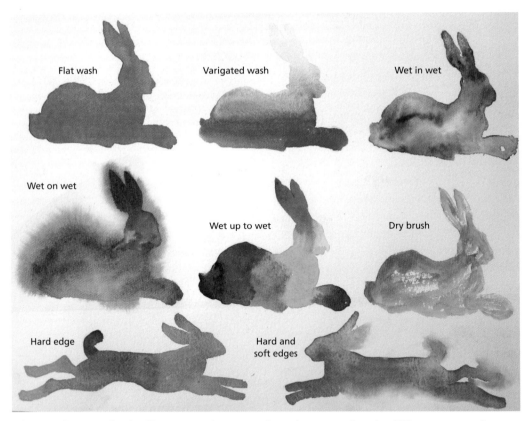

Why not choose a simple silhouette and create a sheet demonstrating the different watercolour techniques? The quality of your edges is crucial in watercolour painting. A mix of soft and hard, and lost and found, will create interest and direct the eye – look at the two hares at the bottom of the sheet and consider how different they feel.

The danger period

When watercolour is wet, you can safely add more colour or more water. When watercolour is fully dry, you can safely add thin layers of paint on top without disturbing the paint already on the surface. However, when neither glistening wet nor entirely dry, you have entered the twilight zone. In this danger period, you should leave well alone. Adding watercolour now is likely to lose the transparency of the paint or cause water marks to appear in unintended places. The exception to this rule is if you want to add textural effects, such as with the application of salt; textural techniques often work better in the danger period.

Mastering simplicity

From the use of wet and dry paper and wet and dry paint, there are only four combinations available to you for painting with watercolours. So, watercolour is very simple; it just takes a lifetime to master that simplicity.

Wet on dry – flat wash

The aim is to apply your paint to the paper in an even layer, without streaks. Work quickly, but with purpose: do not panic. Starting with dry paper and a fluid wash of a consistency like that of skimmed milk, with your work angled at about 10 degrees, load your brush fully with paint but so that it doesn't drip. With your brush held at an angle of 45 degrees to the paper's surface, paint a horizontal line of colour in one pass. All along

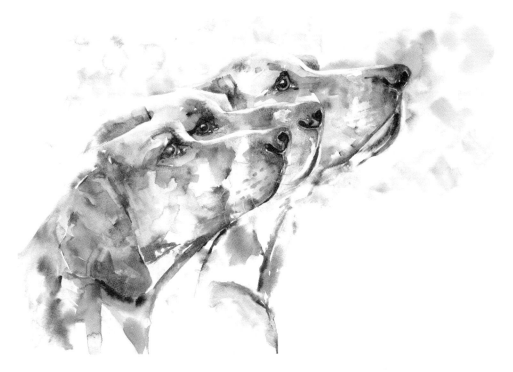

By simply combining water, paint and a surface, you can create magic. This painting of hounds relies on the repetition of eyes and noses, but look closely and you will see all sorts of brushmarks and unexpected colours.

Achieving a flat wash depends on first mixing sufficient paint and then loading the brush with enough of the mix to achieve a bead of paint at the bottom of each stroke. Resisting the temptation to touch up any streaks is also vital.

the bottom of this brushstroke, you will find a small bead of liquid; if not, you need to load your brush more fully with the paint. Reload the brush without dipping it in clean water, then paint the next line of the wash such that it slightly overlaps the previously painted line, picking up this bead of liquid. When you have finished, use a thirsty brush – that is, a clean, damp brush – to suck up the excess paint of the bead. Then, lay your work flat to dry. Do not be tempted to go back and fix any streaks – you will make them worse.

Wet on dry – graded wash

A graded wash goes from light to dark or vice versa. Working dark to light is easier. Turn your paper upside down if needed. For a dark-to-light wash, work as for the flat wash, but, instead of using the same strength of paint throughout the painting of the wash, add a little water with each successive brushstroke. Aim to get a smooth transition.

Wet in wet

The random mixing of colours on the paper's surface is very characteristic of the medium and is a wonderful way of working. Wet the shape that you wish to paint first, then drop in colours. To keep some control, you might let the water sink into the paper before applying paint or use creamier (drier) paint, which will not flow as far in the wet area. Be aware that the water on the paper further dilutes your paint, so you may need to adjust how much pigment you use, to achieve the tone you are after.

Wet on wet

If the entire paper is wet before applying paint then you will obtain very soft edges and lose a lot of control. You may need to wait until the paper, and any applied watercolour, is dry and then glaze on top to regain some definition.

Glazing

For this technique, which exploits the transparent properties of watercolour, layers of watercolour are painted over the top of dry paint, with each layer acting like stained glass. A red layer over blue will create the illusion of purple.

Growing a wash

This method is a more controlled way of allowing colours to mix on the paper. First, a small area is painted, then the colour being used is adjusted or changed and the shape being painted is continued by applying the paint to an adjacent area of paper; there will be mixing at the edges as both areas of paint are still wet. The colour of each brushstroke is altered until the intended shape is complete.

Dry brushing

Excellent for adding broken texture to a piece, this technique is used extensively in landscape painting. It can be achieved only on a NOT or rough paper: the paint hits the peaks and misses the valleys of the paper. Having loaded paint on to your brush, dab most of it off with a sponge or kitchen paper. Using the side of the brush, lightly sweep across the paper's surface, so that you obtain speckling of the colour.

Blooms – how to avoid, how to obtain

Water marks, cauliflowers, blooms – call them what you will. Whether you consider them beautiful or a pain, they are a hallmark of watercolour. They occur when the brush is wetter than the paper's surface. So, if you want to make them happen, add further water or watery paint into a drying wash. If you wish to avoid them, add only more-concentrated paint into a drying wash. If there is less water on the brush than on the paper's surface, you will not get blooms.

The joy and utility of a thirsty brush

A thirsty brush is a jolly useful tool and can be used to achieve different effects. A clean, damp brush can softly lift excess colour or suck away surplus water in a far more controlled manner than simply dabbing with a bit of tissue.

Handling edges

The edges of each area of colour make an enormous difference to the feel of the painting. Hard edges – where the colour stops suddenly – invite attention. They can be harsh; they can be energetic. Soft edges – where the colour gradually fades out – are calm. They fade into the background, or they can create a sense of movement.

Lost edges are when you cannot discern where the actual edge is, whereas a found edge is defined by the objects around it. Mixing these types of edges draws the viewer into the painting and adds a sense of intrigue.

Aim to vary the quality of your edges, probably by using hard ones at the centre of interest and soft ones in the supporting areas. Too many soft areas and your painting will look like a blob; too many hard ones and it will look clumsy or erratic.

Colour mixing

We all know that red and yellow make orange, but you have several options of how to mix those two colours that impact the outcome. They can be premixed directly in the palette, which produces a consistent and potentially boring outcome. One can layer the red, wait for it to dry and then lay the yellow over it. This is called optical mixing. It tends to produce a more interesting orange, as the red and yellow will vary slightly across the area of colour. Of course, you could start with the yellow and that would produce a different effect. Finally, using a wet-in-wet approach, you could wet the paper and then drop red and yellow paint into that water, so that they mix randomly. From a distance, the impression of orange will be given.

Look to maximize the interest of your colour mixes.

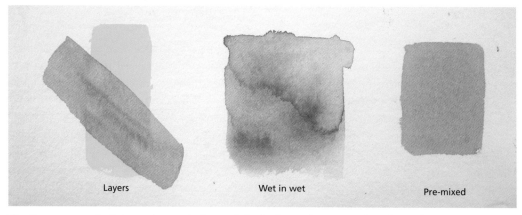

<div style="text-align: center;">Layers Wet in wet Pre-mixed</div>

The three ways of mixing colours – in layers (glazing), wet in wet, and traditional premixing in the palette – give three different results.

Value colour switching

We have seen that tone gives the illusion of volume to your painting, so what is the role of colour? It's to give emotion and atmosphere to a piece. If you want to capture the essence of the animal, rather than making a 100 per cent accurate rendition of its colours and markings, you should apply the concept of value colour switching. In essence, you can swap any colour for another as long as their values are the same.

To test this, choose five different colours. Complete tonal swatches (use the back of an old painting to make strips) for each colour, aiming to obtain seven even steps from full strength to the palest value. Once dry, cut these strips into squares. Now arrange them with the darkest tones together, irrespective of hue. Carry on in this manner until you have put all the palest squares together. To test whether you got it right, take a photo of the arranged squares and convert it to black and white. You should have equal shades of grey for each group of squares. You will find that some colours are simply incapable of achieving the darkest tones – for example, yellow can't. So, in your painting, you could substitute purple for a dark brown and a pale value of any colour for a light area. Of course, you need to take into account whether colours 'go' with each other, but substituting tone is how a rainbow zebra still looks like a zebra.

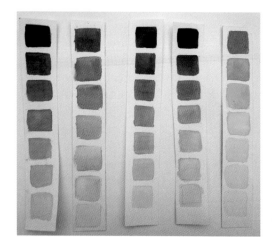

ABOVE: **To understand how to successfully swap colours, first create a few tonal strips.**

Drying your work

Is it dry yet? This is important to know, because watercolour dries up to 15 per cent lighter than when it is wet. You will need to adjust your pigment-to-water ratio to take this into account. Your work looks dry, but is it? Feel it with the back of your hand. If the paper is cool, there

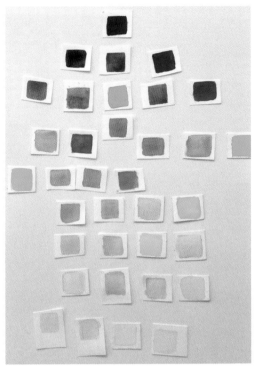

Colour-value swapping is the technique by which two colours of equal tone but different hue can be successfully substituted.

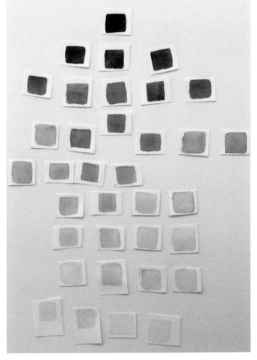

Test your accuracy at colour-value switching by taking a black-and-white photo.

is still moisture in the paper. If it is room temperature then you are safe to proceed. You can use a hairdryer or heater to speed the process; however, do use caution. Simply blasting a wet surface with air may cause runs and push the pigment in a direction you do not desire. Overheating the surface may change susceptible pigments, and, if you do not let the paper come back to room temperature, you will get uneven drying through the next layer of your work.

Textural techniques

Although watercolour is a flat, two-dimensional medium, you can certainly create the impression of texture by breaking up the pigment in different ways. You will find that different pigments behave in different ways, and you can learn which watercolours react best only through experience. Generally, a damp wash will take texturing materials better than a very wet or a dry wash.

Sometimes a brushmark is just too predictable. A spirit of adventure and experimentation lets you bring an added dimension to your work. However, a word of warning. Adding texture to watercolour can be addictive – the adage less is more is relevant. Too many textural methods in one piece will leave the eye nowhere to rest. Repetitive use of one single technique may become a cliché. So, though you love a particular technique, always ask yourself 'what does this bring to the party?'. Don't let effects become intrusive or detract from your painting. While you should never be afraid to try new ways of working, don't overdo them, and ensure that they integrate seamlessly into your work.

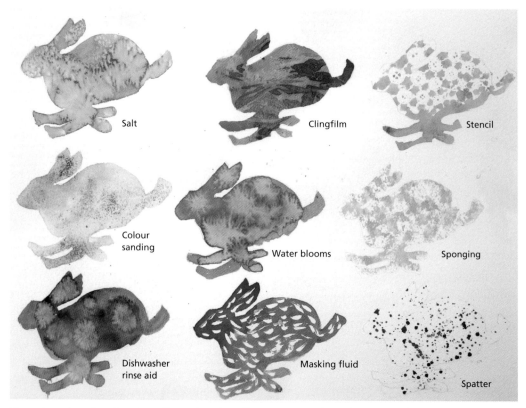

Salt

Clingfilm

Stencil

Colour sanding

Water blooms

Sponging

Dishwasher rinse aid

Masking fluid

Spatter

Though watercolour is a two-dimensional medium, you can place the watercolour pigment to create all sorts of effects.

The range of possibilities is limited only by your ingenuity. But, before using the techniques in 'real' paintings, it is a good idea to make yourself a reference sheet.

Sponging

Natural sponges can be manipulated to give random paint marks. Wet your sponge first and then squeeze out excess moisture, otherwise it will suck up large quantities of paint. You will need to mix a fair amount of paint regardless, as the sponge will still absorb plenty. Controlling the amount of paint on the sponge is important if you wish to avoid the formation on blobs. It is also important to rotate the sponge slightly between dabbing, otherwise you will get a repetition of the same pattern, which will look far from natural. The effect can be built up wet on dry with multiple colours or the density and tone of the mark can be built up with just a single colour.

Printing

Many different items can be used to print watercolour on to your surface in a similar way as with sponging. Some of the most useful items for printing are textured paper towels and the edges of card and credit cards.

Spattering

On dry or wet paper, spatters can break up an overly hard outline, lead the eye or add textural interest. However, spattering can be prone to overuse, with animals ending up looking like they have measles.

Paint can be spattered in different ways. Some like to use an old toothbrush loaded with paint and to draw a thumbnail over the bristles – this tends to create a fine, directional spatter. For more circular drops, a brush can be loaded with the wash and then be tapped on a finger so that the drops fall in the right area of the painting. A paper towel is useful to mask off any area to be protected, or, should you wish for a crisp outline to the spattered area, a stencil can be cut to define the area of spatter.

Larger drops can be carefully placed to help lead the eye around the composition. A large brush jerked in a downward direction should produce decent-sized drops, or a syringe or pipette loaded with paint can give greater control of paint placement.

If you accidentally spatter your work with a single spot, you will find that it looks like a mistake; however, by adding a few more spots, the overall effect looks intentional.

Blowing

A short, sharp puff of breath into a pool of liquid paint on the paper's surface will create a random stream of thin lines. A straw allows you to direct these blow lines.

Spraying

A small water spritzer is very useful to soften edges or to pre-wet your canvas; you can also fill it with diluted paint. Spraying through a stencil gives an interesting pattern, or you can mist a glaze over an area to avoid disturbing the previous washes.

Adding salt

This, along with spattering, are the two texture techniques most prone to overuse. Paint a fairly intense wash, and then sprinkle a small amount of ordinary table salt into it as the sheen is starting to go. Wait for the magic: snowflakes appear. When everything is absolutely dry, carefully scrape off the salt crystals with a fingernail. Rock salt will create larger marks, and Epsom salts will create a different shape of mark.

If you use the salt too soon, you will simply end up with a salty puddle of paint. If the paint is too dry, there will be no effect. This technique works more dramatically with some pigments than others. For reference, Indian ink on canvas takes a salt texture in a fabulous way. Timing is everything.

Using cling film

Cling film (Saran wrap) can be an excellent way of breaking up a wash by giving geometric striations of colour and tone.

The cling film is either crumpled or stretched out over the fresh wash (of a single colour or variegated). The wrinkles of plastic can be manipulated to give the desired effect on the underlying paper, so move the plastic around until you get a pattern that you like. Leave the cling film in place for the paint to dry, but note that you may need to weigh it down.

If you take the cling film off when the paint is still damp, you will get a softer mark; if the cling film is weighed down and left until the paint is

dry, you will get a crisp result. Similar effects can be obtained when you use foil and tissue paper (but use acid-free white paper, as colour will bleed from coloured paper). You could leave the tissue paper in place to create a subtle collage effect, should you wish (see the section 'Collage' in Chapter 9 for more information about this approach).

Using dishwasher rinse aid or alcohol

Placing a single drop of either dishwasher rinse aid or clear alcohol into a drying wash creates a characteristic fisheye effect, with a dark centre and a paler circle around it. Fabulous for nebula or underwater scenes and, frankly, just fun to do! If the wash is too wet, the effect will disappear as the water runs back to where it came from. If it is too dry, the liquid will sit on top of the paint and do little. You can run a few drops of such liquid through a wash to encourage the creation of more dramatic blooms.

Sanding watercolour pencils

While watercolour pencils are very convenient for working with en plein air, they do not always give the intensity of colour that artists are looking for. However, with a little imagination, they can be very useful in creating a subtle textural effect.

Gently rub a coloured watercolour pencil across the surface of a piece of sandpaper, allowing the resulting watercolour dust to fall into and stick to a pre-dampened area on the paper. This creates a fine speckle of colour. Different colours can be built up, layer on layer. The dust will stick to a damp surface only. If the surface is too wet, the colour will dissolve and form a wash.

Warm-up exercises

Handling two-colour mixes

Choose the silhouette of an animal that you like and sketch its outline. Now, starting with one colour, paint in the animal's shape to about the halfway mark. Working quickly, use a different colour to paint from the other end of the shape so that the edges are still both wet when and where they meet. Tilt the paper to get interesting mixes of colours. Now, repeat with other colour combinations. Which ones work well together?

Painting feathers

Learn to control the merging of colours and the quality of your edges through growing a wash.

Find a feather to act as your inspiration. Really look at it. Note the central quill (rachis); is it offset? Observe the direction that the vane barbs come out of it. Look at the downy afterfeather and the individual barbs. Now, decide whether you want to paint this feather in its actual colours or with a made-up selection of colours.

Sketch in a light outline. On dry paper and using your largest round, start at the top and work down, leaving flecks of white to suggest occasional separation of the barbs of the vanes. Change colours as you go to allow them to merge. When you get to the hollow shaft at the end, use the wrong end of your brush to paint it. Changing the quality of your marks adds to the visual interest of even the simplest subject. Maybe pull out the down with the wrong end of your brush too.

Wouldn't it be nice to have some soft edges? Use a clean, wet brush to paint up to the edge of the feather with water and then let a little of the colour bleed away. If you have a fine sprayer, try gently spritzing the edge (use your hand to shield parts of the painting that you do not want

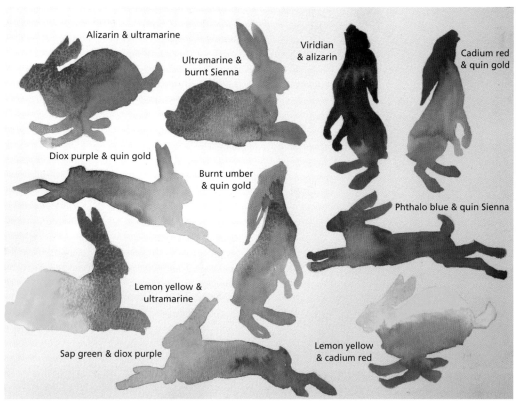

Alizarin & ultramarine

Ultramarine & burnt Sienna

Viridian & alizarin

Cadium red & quin gold

Diox purple & quin gold

Burnt umber & quin gold

Phthalo blue & quin Sienna

Lemon yellow & ultramarine

Sap green & diox purple

Lemon yellow & cadium red

Two pigments can mix to give an infinite number of colour and effect possibilities. These hares were rather more fun to paint than simple swatches.

to spray). If you want to lighten any area to give a glossy appearance, while that area is still wet, lift some of the pigment by using a thirsty brush. If the feather has markings, you can either lift some paint to depict them, if they are lighter, or drop in colour to the damp wash to get soft markings, if they are darker.

Now, repeat the steps of painting the same feather, but dampen the paper first.

Let this second feather painting dry and then analyse the results. Which bits of the painted feathers do you like? Can you see how the white areas suggest the form of the feather? Do you like the soft and hard edges? Can you see how the variety present helps your eye move round the subject? If you want to imply more detail, you can paint a second and even a third layer on top.

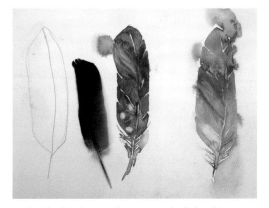

A simple feather makes a wonderful subject to explore how the pigment behaves on both wet and dry paper and to explore lifting out and edge control.

We read so much information from shapes and edges, and nowhere can this better be demonstrated than in a silhouette. Start by creating a simple wash background.

Painting silhouettes

To practise wet-in-wet and glazing techniques, and to better understand how much shapes and edges tells us, have a go at using simple silhouettes.

Select three colours – harmonious or contrasting. Now, create an interesting background wash, wet in wet. Don't go too dark, otherwise you will not be able to achieve enough contrast. Allow this wash to dry completely. Do the patterns that you have achieved remind you of anything? You can turn the paper on its side, to view the wash from another angle. Now, using richer mixes of the same colours, work a silhouette on top in much the same way as you painted the feather.

Remember that our eyes will read detail that is not present.

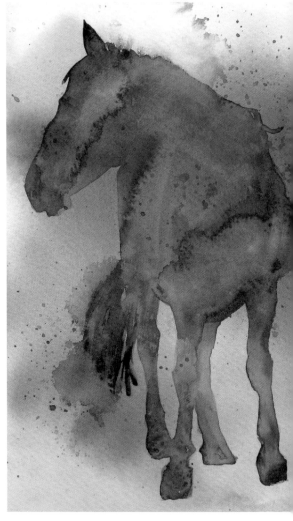

Working on your dry background, paint a wet-up-to-wet silhouette. Such a silhouette is very impactful.

When you come to paint shadows, remember the richness of colour that you achieved here by layering different colours. It would not be half as beautiful if you simply used a flat black, would it?

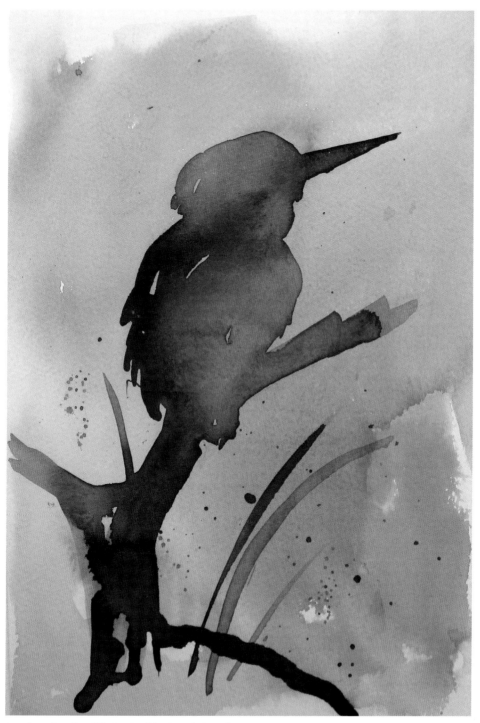

Our imagination fills in the blanks of the silhouette – you immediately know that this is a kingfisher.

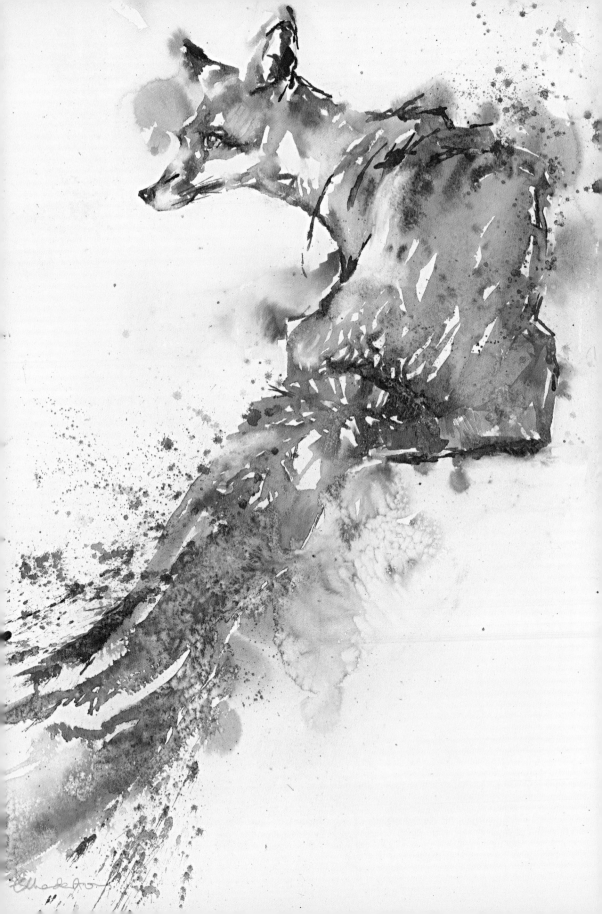

FUR, FEATHERS AND FEATURES

Every species has distinguishing features, so capturing them accurately is key to getting down the essence of the animal on paper or canvas. The balance is to achieve an expressive image while making sure that it is anatomically correct. If you deviate from this, at best, your art will look caricatured and, at worst, it will look plain wrong. It is your decision as an artist as to the level of detail you wish to render and how loose your translation of the fur, feathers and features will be.

Eyes

The locations and shapes of the eyes and pupils are very distinctive for each species. Prey species watching out for danger have eyes on the sides of their heads, to give all-round vision, while predators rely on binocular vision, so their eyes are at the fronts of their skulls.

If you cannot see an eye in a painting, it tends to feel impersonal, so you may wish to introduce a glimpse of one (think Highland cow). Try not to put human eyes on to animals!

Once you add an eye to a painting, you can see the whole creature come to life, so it is really worth practising until you fall in love with painting them. I would always suggest starting with

OPPOSITE PAGE: *Tail of the Unexpected*, **35×55cm, watercolour on paper. You are trying to capture the essence of the animal, rather than every hair and whisker.**

the eye. Should, for whatever reason, the painting of the eye not be successful, the whole painting will fail; far better to do this at the beginning of painting a piece rather than after several hours' work. Eyes are spherical and set into the skull, so you do not want them to look like they have been sewn on at the end. Painting the eyes at the beginning ensures that they are embedded properly into the rest of the head. Another point to remember is that eyes are moist; therefore, a highlight is important.

There is a lovely Chinese story about painter Zhang Seng Yao. When asked to paint a dragon at Jinling Anle Temple, he painted four dragons but left them without eyes. He explained that the eyes are the spirit of the dragon and that, if he added their eyes, the dragons would fly away. Everyone insisted he add them, which he did reluctantly for two of the four. They promptly broke through the wall and flew into the clouds, leaving only the two dragons with no eyes on the walls.

When painting an animal straight on with both eyes visible, do not make the eyes identical. It is very confusing to the viewer, because they don't know where to look first. Try to make the eyes subtly different. Decide which is the most important and make its edges a little sharper or colours a little brighter. A difference of a few percentage points will make the overall portrait more pleasing.

There are three main eye forms, and they are really easy to paint in watercolour, as this is a medium that is full of light.

The painted eye – or eyes – of the animal is essential and determines the success of the overall painting

Old English sheepdogs and Highland cattle may be the exception to the rule about eye forms.

Simple eye

The simplest eye is a circle with a white highlight; this eye form is often found in birds (see the goose-head example featured below left) but also in rodents. The secret is to leave small flashes of white that will indicate moist lids around the eye. Once you have the circle in place, with clean water, paint around it, leaving a tiny gap of dry paper. Then, bridge the gap in a couple of places, and watch the eye colour move out to start forming the surrounding feathers or fur.

Eye without a visible pupil

If the eye is larger, you need to do a bit more work to make it look like a sphere. Though all eyes have pupils, they may not be visible, for example, as in a barn owl. The secret is to really observe the animal's eye and see what is going on. Paint the eye shape (don't assume it is a circle, it might be elongated), leaving the highlight. You may need to simplify the highlight, and do make them consistent, but not identical, if both eyes are visible. While the watercolour is still damp, use your thirsty brush to sculpt a soft highlight, then continue painting outwards, leaving white gaps for the eye membranes, as before. You might want to drop in a different colour too, for example, a little turquoise into a brown eye.

LEFT: **Eyes fall into three categories: simple ones, ones with no discernible pupil, and ones with a distinct pupil.**

RIGHT: **Don't forget that an eyeball is really a ball – here, that of a barn owl. Using a thirsty brush to pull out a soft highlight helps to make it into a sphere.**

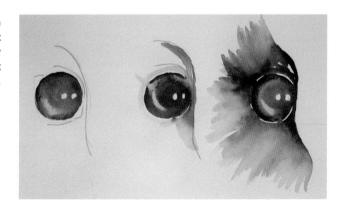

BELOW: **A more complex eye – here that of a cat – needs to be built in layers, by observing and simplifying highlights and shadows.**

Eye with pupil

This will need to be built in layers. If you are not familiar with the animal, do a quick sketch, working out the overall shape of the eye, observing the highlight, shadow from the brow bone, and so on. Start by painting the iris, including where the pupil will be, and leaving the highlight. While the paint is wet, touch in a little colour at the edges that will feather through the already applied watercolour to form the flecks that you see in the iris. Using your thirsty brush, create the illusion of a ball as before. You can start to paint around the eye. I like to have some of the iris colour run out into the fur. Once all of the paint is dry, observe the shape and position of the pupil of your subject and then place it carefully on to your painting, reserving the highlight. This might be a good time to put in some shadow under the brow, depending on the light direction. Again once the paint is dry, using a blue mix, put in the pupil behind the highlight. You can usually see it on the subject.

Fur

Our aim when painting loosely is to give the impression of the coat and not include every hair. Do consider where the light is falling and what highlights it leaves. A black dog is not matt black: there may be blue or green in its coat. Working wet in wet is your best option to achieve wonderful fur texture.

Detail is more visible at the edge of a mass, so concentrate on gaining a beautiful edge for the fur. For a more distant animal, dry brushing will be effective. Wet fur might be suggested by using cling film to place the pigment. Rarely would I suggest using a fan brush with the aim to execute each shaft of hair. If you really observe the fur, you will see it often clumps so that, to render it effectively, you need to paint the shadows behind the clumps.

Granulating colours may also be effective in capturing the effect of fur. Remember that the rougher the paper the more pronounced the granulation will be and also that the more water you use the more the paint will granulate.

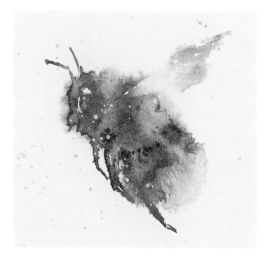

The wet-in-wet technique is great for achieving a fuzzy texture.

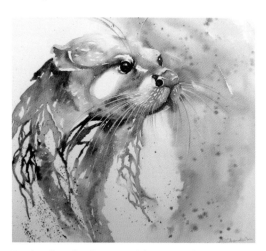

Fur is often in clumps, with texture being more visible at the edges. The wet fur here called for a harder-edged approach.

Now, observe your animal's markings and see how they follow the contours of the body. If it is a spotted animal, the spots will be foreshortened as they appear at the edges of the body and distended as they stretch across areas of roundness. Using markings effectively will give a wonderful volume to your animal.

Fur does not grow in one direction, and, though it may cover the body, it reveals the form of bone and muscle underneath. As you paint, feel as if you are stroking the animal with your brush. Should you accidently skip a spot, the resultant light mark will be entirely plausible and add to the life of the drawing.

Feathers

Did you know that there are seven broad types of feathers? Given that each has a different structure and purpose, you are likely to want to use a variety of techniques to render them. These feathers appear in definite tracts, not at random, so ensure that yours do too. Though I do not believe that you have to count the feathers present of each type, the feathers that you include in your painting need to be plausible.

Wing feathers are asymmetric with a more rigid leading edge that prevents mid-air twisting. Arranged in a fan shape, most tail feathers, or rectrices, feature an interlocking structure similar to that of wing feathers. Typically, birds have six pairs of feathers on the tail. Contour feathers cover the body and streamline its shape and are arranged in an overlapping pattern. Mostly hidden beneath other feathers on the body, semiplumes have a developed central rachis but no hooks on the barbules, creating a fluffy, insulating structure. Similar to semiplumes with little or no central rachis, down feathers are relatively short and positioned closest to the body, where they trap body heat. Being short, simple feathers with few barbs, filoplumes function like mammals' whiskers to sense the position of the contour feathers. Bristles are the simplest feathers, with a stiff rachis that usually lacks barb branches. Most commonly found on the head, bristles may protect the bird's eyes and face.

By rendering a few feathers in more detail, the viewer will infer that the rest of the body is similarly covered.

Blowing at the edges of a newly painted wing shape can create an interesting impression, while shaped brushstrokes, perhaps made with a dagger or filbert brush, can depict individual flight or tail feathers. Salt application or wet-in-wet work can create a sense of down. Ink, pencil or crayon detail, in limited places, may add enough interest to a larger area of feathers. Working with creamy paint into a damp area will give soft edge markings, and lifting out is usually more successful for the creation of white spots, to avoid it looking as though you have used a hole punch on the feathers.

Noses

The philtrum is the central line running down many animals' noses such as that of a dog or a cat. The shape of nostrils is distinctive, as is their texture, so observe and don't assume.

Dogs' noses are covered with flat oval shapes. Cat's noses are related to the colour of their coat, and their nose patterns are unique like fingerprints. For a rabbit's nose, the nostrils are hidden. The shape of a horse's nostrils changes with mood – beware of the flare!

Using a fine rigger brush to draw the pattern of the nose's texture in clean water and then touching in colour to follow its path is a successful way of implying texture.

Nostrils should not be black, but they are likely to be very dark and are successfully rendered by mixing a dark from the colours that you have used elsewhere in the painting.

Feet

Paws, hooves, trotters, call them what you will, they can be hard to see on a live subject. So often they are hidden in grass or mud. I personally find a clump of grass obscuring the animal's feet a

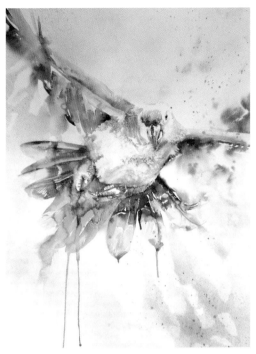

You don't have to show every single flight feather, but those that you paint definitely have to follow the pattern of placement, so first take a little time to observe how they grow.

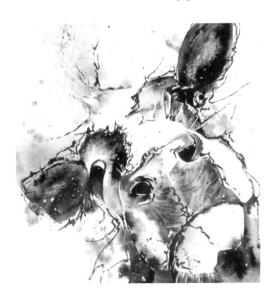

Who can resist a cow's nose? Certainly not me. I used cling-film texture here, but I often paint the desired pattern with clean water before dropping in colours to then mix on the paper.

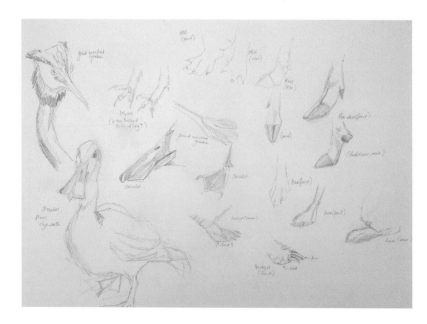

Paws, hooves and other feet forms are often obscured in the wild, so a crib sheet drawn at the local natural-history museum may come in handy.

cliché. Use an afternoon at a good natural-history museum to draw as many reference feet as possible for any animal or bird that you think you are likely to paint one day. This reference sheet will be invaluable. Look for differences between front and hind legs, and consider carefully the number of toes.

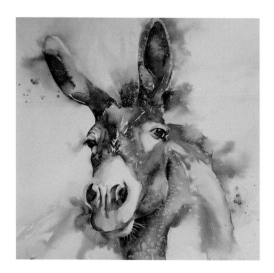

Ears express character and emotion. It is worth considering their placement to make interesting negative shapes around them.

Ears

Human ears are a better unique identification mark than are fingerprints. Though the lobe descends a little with age, you are born with your ears fully formed. In animals, ears are equally distinct and often very expressive. Beware the cat with laid back ears!

Painted ears often benefit from having soft edges, to imply movement, or spatters, to give the impression of a twitch being made. Such treatments will also prevent the ears becoming too much of a focus in a painting.

Beaks and mouths

Mouths don't tend to be the dominant feature in many animals, the exception being birds, where the shape of the beak is critical. Getting birds of prey to look right is about their beak – too rounded and the bird will look like a parrot, too long and it will look like a vulture. Beaks look different face on and in profile. Note that birds' mouths are wide and extend quite far into the face.

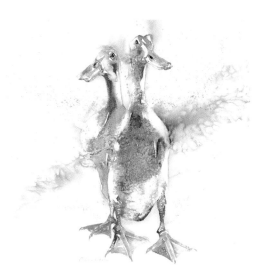

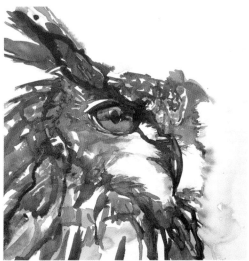

Mouths of animals are not always characteristic, but a beak really can define a particular bird.

The beak length of a bird of prey impacts whether the bird looks like a budgie, an owl or a vulture, for example.

Tongues are a matter of taste. Personally, I do not like them in animal portraits – consider that it can end up looking like the dog has caught a naked mole rat. Should you wish to put a tongue into your work, study its length, colour and texture carefully: giraffes have blue-black tongues, and cows' tongues are surprisingly long.

Other features

Horns are a fantastic opportunity to introduce contrasting texture – hard, graphic lines against the soft wool or coat. Look carefully at the colours in the horn, and do not be afraid to introduce an element of surprise. The wattle and comb of a chicken have an interesting texture, and they can be painted successfully in a similar way to noses.

Scales on fish overlap in mysterious patterns, but you certainly don't need to paint each one. Consider using a texture created by bubbles in your paint or rendering the overlapping pattern in only very few areas, to concentrate on the overall markings.

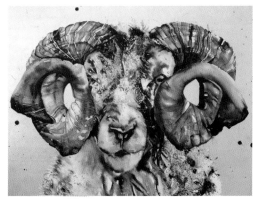

Horns introduce a contrast of hard against soft.

Creating a sense of movement

We have seen that soft edges create a sense of movement. Diagonals in your composition can also create direction, to give the impression of action. They do not need to be in the actual subject but can be in the background, the brushstroke or the placement of dots and splatters. Direction lines may help, but avoid the cartoonish ones.

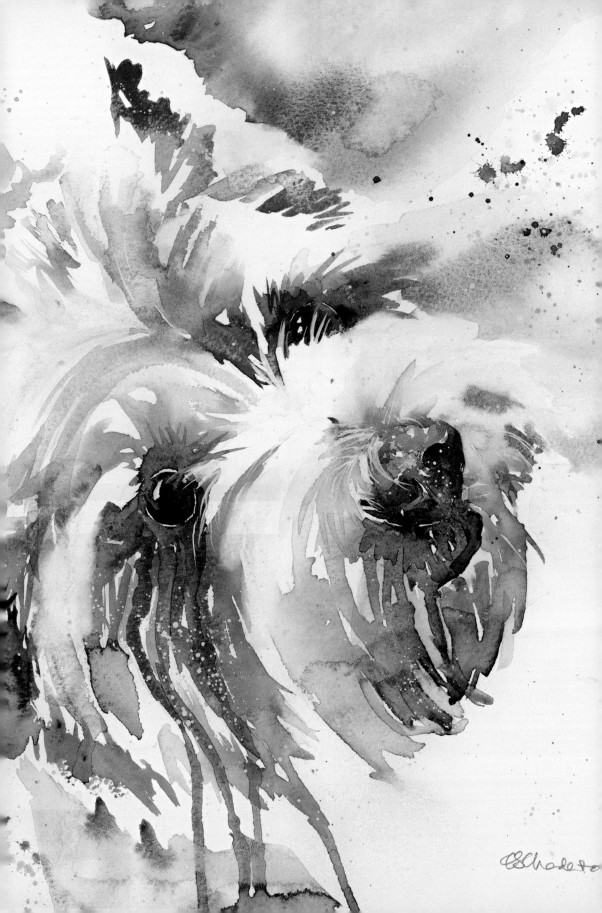

WATERCOLOUR

Having gained some control of watercolour from the exercises in Chapter 5 and seen how the different features of the animal can be created in Chapter 6, it is time to put things together and start painting animals.

Monochrome

If you haven't painted for a while or you are new to watercolour, an excellent way of easing yourself into understanding and controlling the flow of the water is to complete an animal study in a single colour. This allows you to really concentrate on form and texture, without any concern for mixing the correct hue.

SEVEN POINTS FOR SUCCESSFUL WATERCOLOUR PAINTING

1. Transparency is key.
2. Let the water do the work.
3. Worry about tone, not colour.
4. Keep your whites and lights.
5. Repetitive brushmarks can be boring – make a variety of marks.
6. Change up your edges – hard and soft, lost and found.
7. Stop too soon, not too late.

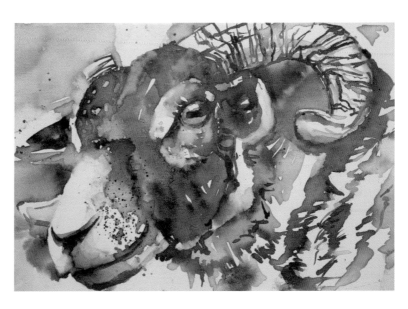

OPPOSITE PAGE:
Westie, 35×35cm, watercolour on paper.

RIGHT:
A monochrome painting is an excellent way of getting to grips with the subject matter and new techniques. By stripping out the need to consider hue, you can really concentrate on getting the tones right.

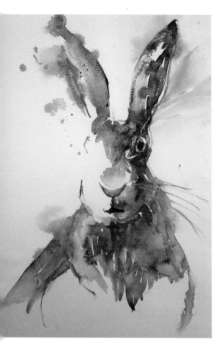

When something good happens, be prepared to stop. I am not usually a fan of painting half an animal, but, when doing this little hare painting as a demonstration, I rather liked the unfinished look. It seemed to sum up the hare's cautious nature.

Watercolours on paper

Step by step: hare

Hares are a perennially popular subject. The chances of seeing them close enough to sketch are sadly low, so you may wish to head to a natural-history museum to study specimens (see the section 'Where to look for animal encounters' in Chapter 2 for an example). Supplemented with photographic references, you will be able to paint this iconic animal.

1

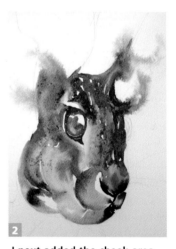

2

Start with a thumbnail and then plan your palette. I really wanted the focus here to be on the eye. I used phthalo turquoise, burnt umber, neutral tint and quinacridone rose. I sketched the basic outline on a NOT 140lb paper and then started with the iris, working outwards to ensure that it was really bedded into the skull, even though hare's eyes are bulbous. I was careful to leave flecks of white paper and used a little salt on the face area to break up the pigment.

I next added the cheek area, making sure to use plenty of water and obtain lovely wet-in-wet flows of colour. I also softened several edges with water from a spray bottle. This is quite a wild way of dealing with the edges but is a lovely method to encourage spontaneity.

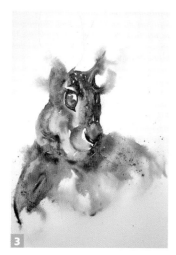

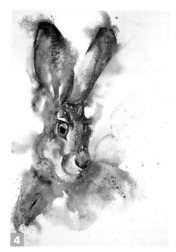

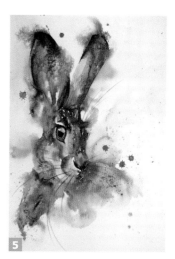

I moved on to the body with the same colours, letting them mix on the paper's surface, and spattered on some burnt umber to hint at the clumps of fur, again softening the edges in places.

Once the eye was dry, it was time to get the pupil in – I am always happier after this point. I also hinted at the second eye. The ears were a whole heap of fun to paint. Starting with a dark mix of neutral tint at the top and then growing the wash down towards the face, I made sure that, on the left, the ear really blended into the head and, once again, softened the edges, to give a sense of twitching. A little more salt was put into the drying wash, to develop interesting marks. With 85 per cent of the painting completed, I let it dry and considered what to do with the background. I decided just to strengthen the washes of colours and introduce more of the rose. Having softened the edges before, much of the background had enough colour already.

Once again, I let things dry, and I then added the whiskers by using a rigger and a mix of the colours used elsewhere in the hare. Adding in white whiskers would have been too stark. I thought a few spatters of the umber would help the eye travel around the picture and build on some of the small spatters that I had introduced into the body. My aim was to make these spatters look random, while actually placing them carefully. For large spatters, I generally use a syringe (without a needle), so that I can release one dot of colour from whatever height I want to, to get either clean circles or more explosion.

Step by step: stag

Another wonderful animal that we are becoming more accustomed to seeing is the deer. I am for-
tunate to be able to watch them occasionally in the field opposite where I live. The ones that I see
aren't quite as grand as this specimen, but you can often get close enough to sketch them in country
parks or at National Trust properties.

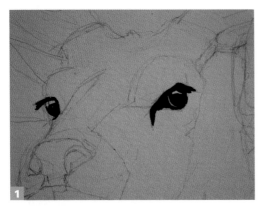

Consider once again what you want to
communicate about the animal. Is it the
branching antlers, the huge eyes or the whiskery
nose? I wanted to emphasize the softness of the
nose, so I completed a thumbnail and took the
antlers off the edge of page; my palette included
burnt umber, phthalo turquoise, Nordic blue (a
mix available from the SAA) and neutral grey.
Sketch the basic outlines of your design on to
your paper, keeping lines to a minimum. Going
on to the painting stage, start with the eyes,
using a dark, strong mix of Nordic blue, leaving
highlights as clean white paper and taking the
dark into the tear ducts.

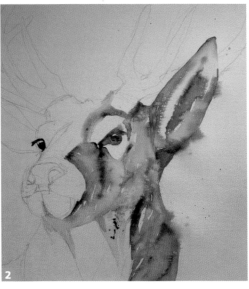

Next, using a wet, clean brush, start pulling some
of the wet colour away from the eyes and move
up into the ear area. Dry brush some areas of the
ear to bring a different texture into the painting.
Spritz other areas with clean water, so that you
now have hard and soft areas.

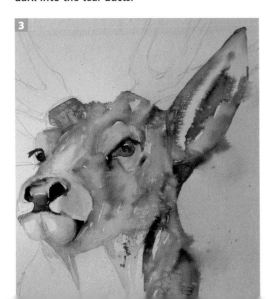

LEFT: Moving on to the top of the head and
the neck, grow the wash in the direction of
the fur, leaving flashes of white paper to
suggest the growth pattern. The nostrils are
very characteristic so are put in very dark, and
highlights are left clean. When the eye has
dried enough, sculpt out a soft highlight with
a thirsty brush. Allowing the eye paint to dry
sufficiently before this sculpting step is crucial;
if I had done it sooner, the paint would have
flowed straight back in.

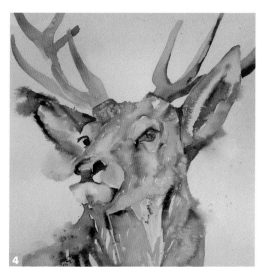

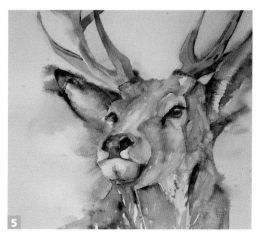

Time for the antlers and the rest of the body. For this piece, I needed to put the antlers on very flat, to ensure a contrast with the pelt. The body was painted more simply than the neck, so that it was pushed back.

With 85 per cent of the painting done, it was time to let everything dry completely and to assess. I decided to put a second layer on the antlers and also painted negatively around the nose area to create the whiskers. I thought I was finished, but something wasn't quite right, so I let everything sit for a while before I came up with a plan.

RIGHT:
I decided that there was a lack of contrast, so I worked washes in around some of the antlers and down the sides of the neck. I hadn't used salt for the stag, but I did introduce salt into the background, to add more interest.

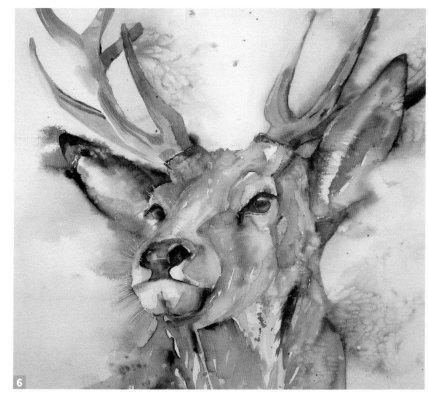

Watercolours on canvas

Both of the previously featured paintings are on the expected paper surface, but what would happen if you were to paint on canvas? With new grounds, you can now prepare an ordinary canvas to accept watercolour. You can also buy canvases ready prepared.

By using canvas, you would not be restricted by size or the need to frame the final work. Given the more three-dimensional nature of a canvas, especially a deep-edge one, canvases are ideally suited for the painting of animals that you want to jump off the surface.

A few pointers

Canvas is rougher on your equipment than paper, so you may wish to put away your finest sable brushes in favour of synthetic ones. Step-by-step demonstrations explore various techniques and differences, but some of the key points are noted here.

1. Plan your composition even more than usual. On paper, you can adjust the composition at the end by cropping or rotation. If the edges are to be hidden under a mount, this is fine, but, on a canvas, it's all on show, so you need to know where you are going. No scissors can come to the rescue!
2. Consider the canvas edges. Do you want to continue the painting on the side edges of the canvas, will you use a frame to hide these edges, or will you leave them white? I like the three-dimensional effect of continuing the painting over the canvas sides.
3. A normal eraser does not work well on canvas, so, if you draw on your image, keep the lines light and to a minimum, unless you want them to show. If you need to erase

errors, I find that a damp Magic Eraser (a melamine abrasive sponge) works best.
4. If you need to mask to retain whites, this is easy on canvas because the surface will not tear. Lifting back to the original white with a damp brush is also more straightforward on canvas than on paper.
5. The paint lifts so readily on canvas that you will find glazing tricky. It is easier if you are direct in your painting. If you really want to glaze, use a very light touch after the previous layer of paint is totally dry. Paint takes far, far longer to dry on canvas than on paper. Schmincke's Aqua Fix is a very useful additive to use if you wish to glaze on canvas.
6. Colours appear brighter and clearer on canvas – it seems harder to muddy them.
7. Textural effects – such as back runs and those achieved with salt or cling film – are often more pronounced. You may need to resist the temptation to use them, as their overuse would detract from your painting.
8. Indian ink performs fantastically on watercolour canvas. You can mix ink and watercolour in exciting ways. Even dried Indian ink can be adjusted on canvas with the enthusiastic use of a Magic Eraser but can be glazed over. Mixed media, collage, metal leaf and so on can all be successfully used with watercolour on canvas.

Before watercolour and canvas can be used together, the canvas must be primed. Several of the large manufacturers produce watercolour grounds; such grounds from Daniel Smith, Schmincke and Golden (QoR) are widely available, while absorbent gesso offers further possibilities. To prepare a primed canvas, you need to apply three thin layers of the ground. Each coat should dry for a few hours before you apply the next, and you must then allow the whole canvas to cure for at least twenty-four hours before painting. For more information about grounds, see the section 'Watercolour ground' in Chapter 9.

Step by step: cat on canvas

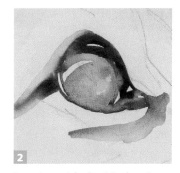

Composition is even more crucial on canvas, as you cannot crop it, so do a thumbnail plan first. Lightly sketch your composition on to the surface in pencil. As it will be difficult to remove, avoid creating dark lines. I planned for my palette to include pyrole orange, burnt Sienna, burnt umber, quinacridone gold and Prussian blue.

Starting with the iris, leaving the hard highlight, I mixed colours wet in wet to create flecks and interest. Taking a thirsty brush, I sculpted a soft highlight. Then, I put in the darks around the eye, leaving small gaps of white to indicate the edges and stop everything merging.

Now, working out from the eye, I developed the cheek area, being conscious of the direction of growth of the fur and leaving little areas of white, to give a hint of the fur's structure. I sprinkled on salt to create a fur texture alongside the wet-in-wet areas of the painting.

Next, I moved up to working the ears, using a spritz of water in places to soften the edges. I also spattered a little water around the ear as an alternative to a soft edge. I had used a huge amount of water on the left ear to get very flat colour, so I let everything dry and settle down at this point.

I waited for the iris to dry before painting in the pupils. The pupil brings it to life! I painted negatively around half of the whiskers, deliberately adding in water to get blooms in places. Once dry, I used white gouache to add in another layer of whiskers.

On a deep-edge canvas, you must consider the edges. I like to continue the image down the sides to give a three-dimensional image. Once everything was entirely dry, I applied three thin coats of matt spray varnish, not forgetting the edges. This seals and protects your painting.

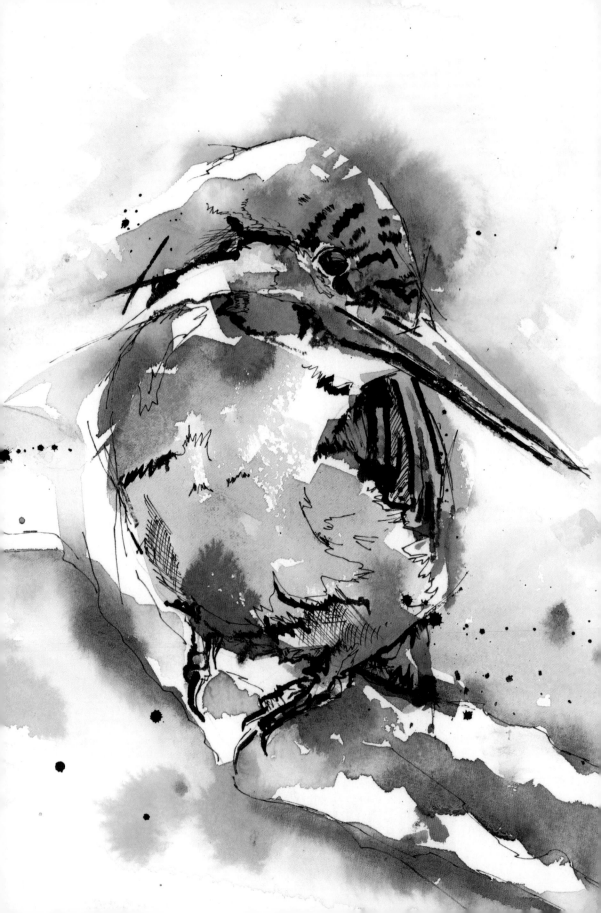

PEN AND WASH

Using pen (or 'line') and wash is a wonderful way of working. If you are looking to loosen up your watercolour technique, it can be a great stepping stone. If you want to take sketches to the next level, it can be perfect. Or you might simply enjoy the contrast between hard lines and soft washes, for its own sake. Think of the pen as the clothes hanger to drape the watercolour on to.

For me, line and wash is at its best when the sum of the ink drawing and the application of the watercolour add up to more than the individual parts. Outlining a painting or colouring in an ink drawing misses the opportunity to bring drama and movement to your work, which is then so much more exciting.

NOT RULES, JUST GUIDELINES

- Many people consider pen and wash to be more suitable for smaller works. Larger work needs a thicker line.
- Simplify the subject – focus on what attracted you in the first place, and go to the heart of it with your painting.
- Do not colour in your drawing or outline your painting.
- A wide range of tones is necessary in any painting.
- Be spontaneous, although you can be detailed – use a hot-press paper in this case.
- The line describes the shape and form of the animal.
- Loose, spontaneous lines seem to work well – try to hold the pen well up its barrel and not to rest your hand too heavily on the paper.
- Broken lines are often more expressive.

- Don't worry if you get a line placed wrongly – just put the right one on to the painting as well.
- Try drawing without taking the pen from the paper's surface, but this doesn't work with a dip pen!
- You can hatch or stipple with ink to add tonal value – consider the light falling on your subject.
- The wash does not need to relate to the line work at all.
- Use wet-in-wet and wet-up-to-wet techniques for the washes.
- Remember, watercolour dries lighter.
- Start with the light colours and then work darker.
- You can go back over paint and add more ink or vice versa.
- Do not fiddle – stop too soon rather than too late.

OPPOSITE PAGE: *Kingfisher*, 35×45cm, pen and wash on paper.

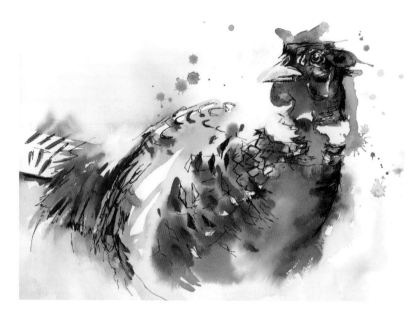

Pheasant, **35×45cm, pen and wash on paper.**

Whether you start with the ink drawing and add colour at the later stages or start with the painting and add definition with ink towards the end, aim for each element to enhance the other. Just remember that, in pen and wash, for once $2 + 2 = 5$.

Saving a failed painting

Sometimes it can be hard to get enough definition and contrast in a watercolour painting. Should this happen to you, pen and ink may come to your rescue. You still don't want to simply outline your paintings, and you need to really consider where the ink can contribute.

Materials

Traditionally, a smooth hot-pressed paper surface is used, to allow a detailed drawing to be made. However, as we are not aiming for the coloured-in-picture look, a NOT surface is used in this case.

Pens and inks

In addition to the pens that we use for sketching, now that we are back in the studio, we can add others to our repertoire.

A dip pen with Indian ink might be a messier option but gives a freedom and expression to your marks that is often lacking with a fibre-tip pen. Indian ink can also be applied with a brush and be diluted, so that you can produce a greyscale painting/drawing before applying colour. Of course, you don't have to use waterproof ink. Some felt-tip pens make marks that are not permanent and give a lovely soft effect when the ink runs slightly when water is applied to these marks. You should check on lightfastness, though, as often the inks of felt-tip pens are fugitive. Ink can be applied with a stick or a stone, for example, to great effect, giving very lively results.

Then there are Chinese inks, acrylic inks and ink sticks. Acrylic ink is interesting as you have the chance to use a white line, which can be most effective.

Planning

It will be really helpful to do a five-minute thumb-nail sketch to work out the answers to some of the following questions – it will possibly save you heartache down the road…. But, as always, rules are there to be broken, and, if accidents happen or your painting takes on a life of its own, you can respond and change your path.

What are you trying to say in the painting and what feeling are you trying to elicit? Think about varieties of tone – where will your dark areas be and your lightest? What roles do you want the ink and the watercolour to play in your painting? And what will be the balance of the two media? I personally think that one or other should domi-nate – again, the rule of thirds – rather than both having equal prominence. Finally, are you going to leave quiet areas in your painting? Some-times, the eye needs a place to rest a while…

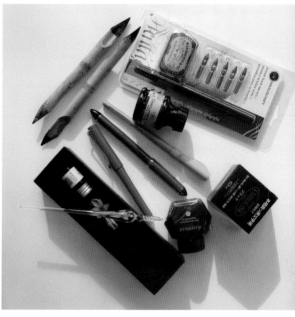

Just a few of the amazing variety of pens and inks available.

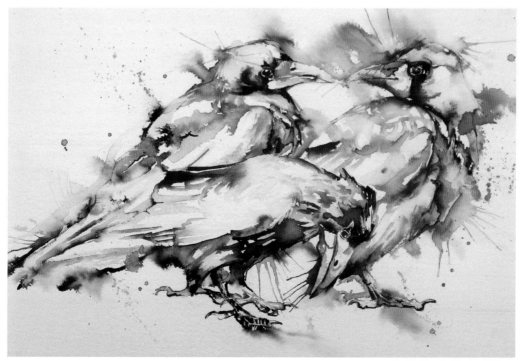

Using only an Elegant Writer pen, I drew these rooks. The ink separates into pink and turquoise when moved around with water.

Techniques

How you do your ink drawing is entirely a matter of preference – but it is worthwhile to experiment. You can use a variety of elements.

- Contour lines
- Criss-crosses
- Crosshatch
- Parallel lines
- Scribble
- Stippling

Some people use very stylized lines or even inked patterns to great effect. If you are using liquid ink, you can consider blowing, splattering or dropping it on to the paper. However, you will not be able to lift or blot this ink, so be careful but brave.

Indian ink runs through wet watercolour and granulates beautifully, so you might consider mixing things up – drawing first, painting second, applying more ink to wet washes…

Consider all of the texturing techniques that you might use: soft edges, hard edges, dry brush, salt, cling film and so forth. You may wish to use them in a judicious manner to avoid your painting becoming too busy. Negative painting can work well with penwork, to avoid the outlined look.

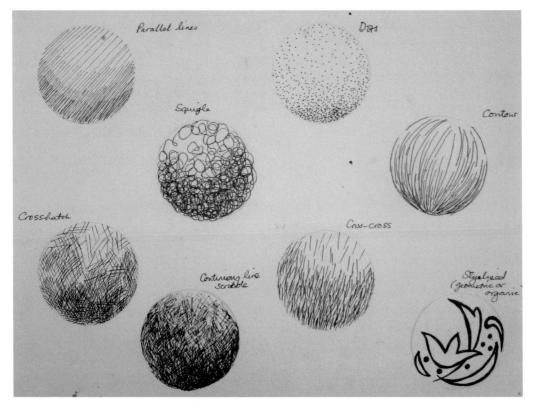

You need to actively choose which style of mark you will use, rather than relying on your default setting. Especially with the fine-liner pens, you need to work hard to inject some character into the lines.

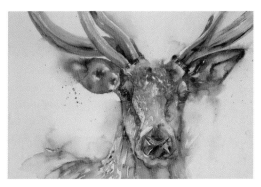

This painting lacked definition, and I was ready to bin it.

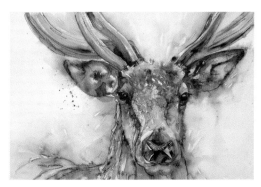

Through the addition of line work, the painting's focus was recovered.

Rescue missions

If you haven't used pen and wash before, you could take the first steps by rescuing a failed painting.

This stag painting (above) just wasn't working for me. I started it as a step-by-step demonstration for the watercolour chapter, but I felt it was missing some punch.

Using a fine liner with pigment ink, I worked on the eyes and immediately felt a lot happier. I then made sure that I used different marks on the antlers than for the fur.

Turning things on their head!

You do not need to do your inking first; if you find it hard to be spontaneous with your washes, do them first, knowing that you will be able to gain more control by using line afterwards. And of course you can always add more colour or more line once the previous application of ink or watercolour has dried. It is far harder to do less, but more is always possible.

The first of these rams was drawn in ink, with the colour being added once the ink was dry. I

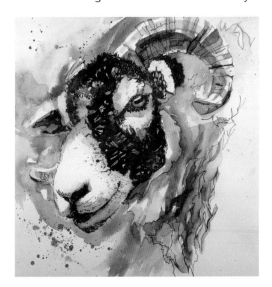

The danger of using ink first is that you do too much, leaving little space for watercolour to play.

The downside of using watercolour first is that you will be tempted to outline your work.

had been heavy-handed with the ink and finally had to add some white ink spatter to break up the black face. This is the danger with applying ink first – it is indelible, so you need to stop too soon and not too late. The second ram was painted first with loose, colourful washes, while avoiding the distinct white shape of the ram's nose. I could then go in with pen and ink to rediscover the sheep from what appeared to be an abstract pattern. You can then add in a bit more colour at the end, if you need to strengthen and define aspects of the subject.

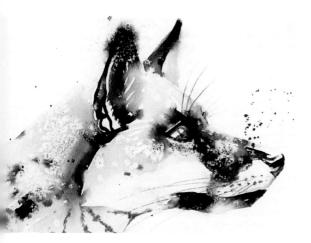

Indian ink works beautifully on a prepared canvas.

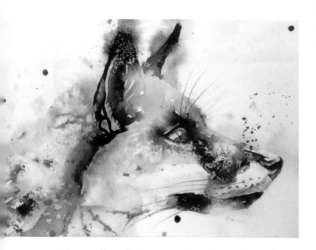

It is usually a fast process to place watercolour washes on top of an ink grisaille.

Ink and wash on canvas

As we saw in the Chapter 7, new surface preparations mean that you can now use watercolours on virtually any surface. Indian ink reacts beautifully on a watercolour ground. Because Indian ink is waterproof, it does not lift easily as ordinary watercolour does. Therefore, working with ink and wash on canvas overcomes one of the major disadvantages of this new surface. Many people are intimidated by ink. It is permanent, they argue, therefore it is scary, in case I make a mistake that cannot be corrected. Though permanent on paper, in fact, on a canvas, by using a Magic Eraser, you can usually adjust the tone of your ink and, in many cases, remove it completely. Thus, ink and wash is far more forgiving on canvas and, indeed, is a joy to work with.

Pens can be used on canvas; however, the surface of canvas is very abrasive, and pen nibs are likely to be damaged. Either use a fine-weave canvas or sand the ground so that it is smooth, to avoid excessive wear of your pens.

The featured before and after paintings are illustrative of a useful approach for ink-and-wash painting. Having painted a grisaille with Indian ink on the canvas, it is quick to add a wash of colour. Once dry, pigment-ink fine liners can be used to add details such as the whiskers. Then, all that is needed is a coat of matt varnish to seal and protect the finished piece.

Demonstrations: basset hounds

I adore basset hounds, ever since a friend had one that used to sleep on my feet and keep them warm while my friend and I were drinking cups of tea.

Step-by-step method with ink first

 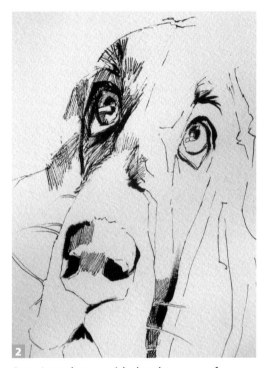

Before starting work on a piece, it's a good idea to decide what roles you want the ink and the watercolour to play. I decided that I wanted a pretty detailed drawing that would carry the colour. I planned to use crosshatching and hatching to catch the character of the basset's coat. I started with broken lines made with a fine-nib pen to map in the main features.

Once I was happy with the placement of the main parts of the composition, I started to develop the drawing. I always assess proportions as I go along, so that, if I notice that something is off, I can usually adjust things and put the right line in. I varied the weight of the lines by using different widths of pens. If I had been using a dip or fountain pen, I could have varied the pressure with which I was drawing to get more expressive lines. In a few places, I tried to follow the contours of the folds of the ears.

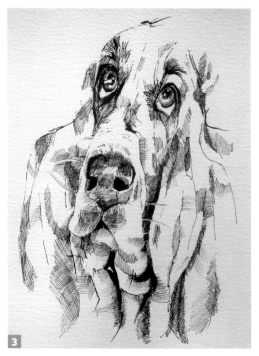

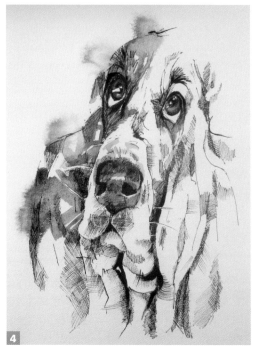

3 The completed drawing still leaves enough room for the watercolour to have some fun.

4 I really tried to avoid colouring in the ink drawing, and, just as previously, I softened some edges with water applied from a spray bottle. But, in other places, I dry brushed the colour, to vary the marks made.

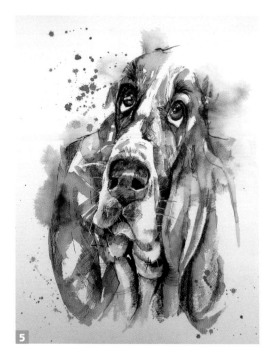

5 Once the main painting stage was complete, I sat back to make sure that I was happy with the balance of the piece. I could have added more pen, if needed. Because the drawing had been quite linear, I decided that a few spots of colour would break things up.

Step-by-step method with watercolour first

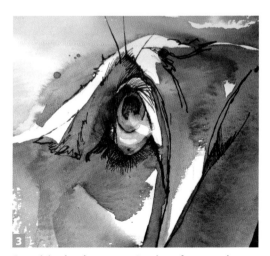

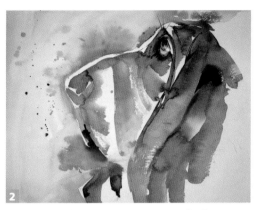

Once the under painting was entirely dry, I took my fineliner and started to work on the eye. I also painted in the iris.

Loving the opportunity to paint another basset, I wanted to capture the beautiful light on Sofie's nose. I started by sketching the basic shapes and then painted negatively around the nose and dropped in phthalo blue to bloom out wet in wet. I made broad strokes of colour, while leaving the eye area alone, as I wanted to paint that more carefully. I followed broad areas of tone and dry brushed in places to get a good variety of marks. The completed painting still leaves space for the ink to do some work.

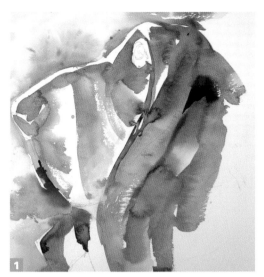

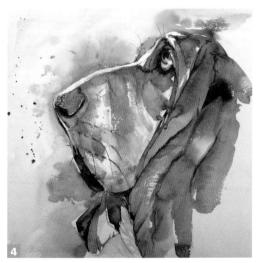

Surprisingly, there wasn't a lot of penwork required, because the paint was doing most of the work.

I defined the folds and edges of the ear and darkened the nostrils. Whiskers are always fun to put in, but you need to restrain yourself and not put in every single one. Once I thought that the piece was finished, I sat back and contemplated. I decided that highlights were needed in the nose area and, to balance that up, I spattered a small amount of white gouache over the jowls and ear and off the top of the nose, to emphasize the light, which is why I had painted this piece in the first place.

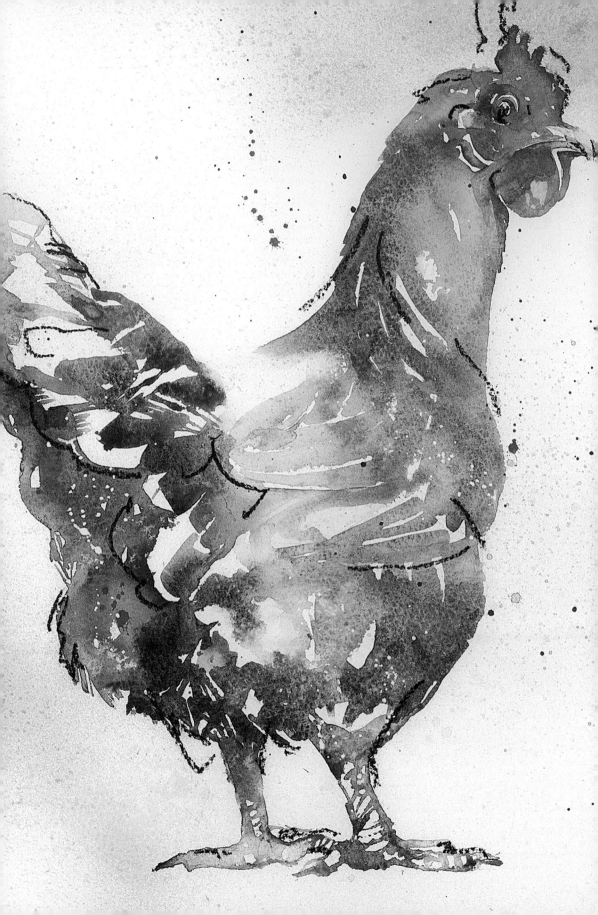

MIXED MEDIA

Watercolour and more

You probably fell in love with watercolour because of its transparency and its immediacy. It can be luminous, and a lot can be achieved in a short period, without the need for noxious chemicals and extended clean-up. No wonder that watercolour is a very popular medium. However, once you have mastered the basic techniques, you may be looking for a new challenge. By combining watercolour with other media, you can really push the boundaries of watercolour painting without losing the qualities that attracted you to the medium in the first place.

Ink with watercolour is so accepted that we do not tend to think of it as mixed media at all, and we covered this combination in the previous chapter.

As a guiding rule for mixed media, you use the wet medium first and anything that will fill up the tooth of the paper last. However, rules are there to be broken. For example, if oil pastels are used first, they act as a resist to the watercolour, but, if they are applied on top of dried watercolour, they can be used in a similar way to soft pastels. Soft pastels are generally used on top of dry watercolour, but, if you wash over pastels with water, you can obtain a similar effect as that achieved with watercolour, though more opaque.

OPPOSITE PAGE: *My Best Layer*, 37×37cm, **watercolour and charcoal on paper.**

Working with pastels

Pastel paintings almost vibrate with colour and, because pastels are applied directly to the surface of the drawing, they are often full of energy. Pastels and watercolour seem made for each other. The flowing colour of the painting combines brilliantly with the directness of the pastel drawing.

You may start off by deliberately wanting to combine the two media, each with a role to play, or you may wish to rescue a failed painting by adding pastel on top. If your watercolour lacks a bit of contrast then pastels may make it pop. Alternatively, you may wish to use the watercolour to build up a tonal foundation or underpainting to allow the pastel to do most of the work. All of these three approaches are valid, though thought needs to be applied to prevent either the watercolour or the pastel looking like a late addition. Your aim should be to contrast hard and soft marks and warm and cool colours and to play to the strengths of each medium.

Materials

Pastels naturally generate some dust. If you have any breathing issues, do consider whether this is the right medium for you, and perhaps consider wearing a mask or using oil pastels instead. Some people with asthma may have a dust reaction, but this is not a toxic reaction. Avoid blowing on to your work, and consider

Paper stumps (centre) are useful for precision blending. They can be cleaned on sandpaper.

Pastels come in a rainbow of colours and a variety of formats.

using an easel, so that the particles fall off of the artwork's surface and can be vacuumed up. The other advantage of using an easel is that you will be standing and, therefore, the marks that you make will be more dynamic.

spray your watercolour with a workable fixative and allow it to dry; afterwards, you should not experience any colour shift. An alternative is to coat the dry watercolour painting with either a transparent gesso or a transparent watercolour ground. Allow this coating to dry and then you will be able to feel the difference to the surface of the painting. Now, you should be able to layer on soft pastel easily.

Papers

A NOT surface has the ideal tooth (texture) for catching and holding on to the pastel, while a hot-pressed surface is too smooth. Depending on the brand of paper you wish to use, you may find that a rough surface is too dominant if you try to use it for mixed media with pastels.

Adding tooth
If you find that your paper does not have enough tooth to capture and hold the pastels, you have a couple of options. First, you can

Pastels

Pastels are available in tints (often numbered from 0, the lightest, to 8, the darkest), so you may wish to start with a selection of colours in a light, middle and dark tint. Having to be creative with a limited selection of colours often leads to a more exciting outcome: after all, you can mix colours by placing strokes of colours next to or over each other.

Caring for pastels
Remove the paper wrapper from the pastel so that you have the opportunity for making both broad strokes, by using the sides of the stick, and more

precise marks by using the ends. Pastel sticks can be stored in their original box or in something home-made of corrugated card, to stop them rolling. If the pastels become contaminated from being stored mixed in a box, you can gently shake them in ground rice to take away the stray coloured dust on their surfaces. This rice will need to be sifted away before you use the pastels. If you prefer and particularly if you wish to develop your pastel work, you may end up with a box each of red, yellow, blue and green tints, which will also help you to find the right colour/tint when needed. If a pastel becomes dirty as you are working with it, just rub it on a sheet of paper to take off any surplus or unwanted dust. Remember, even the smallest fragment of pastel is still usable.

Pastel pencils

Pastel pencils are wonderful for adding detail to pictures and are considerably less messy to use than are soft pastels. They come in an equally wide range of colours, but the pastel within them tends to be harder than for stick pastels, so they can be (carefully) sharpened to a point to allow more detailed applications. Avoid dropping them, as it is very annoying to have a broken pastel 'lead' in the pencil.

Other equipment

A putty rubber – a soft eraser that can be kneaded to a fine point – is useful to take pastel off of the painting cleanly. A stiff hoghair brush can also remove pastel dust. If you want to blend your pastels, a useful tool for you to use is a paper stump. The stump can be cleaned by rubbing it on a sheet of sandpaper. I personally prefer to see the individual pastel marks and think that they contrast better this way with the watercolour elements.

Techniques

Remember that you do not want to fill the entire tooth of the paper. When you have put layer over layer until the next one starts to fall off, this is the equivalent of creating 'mud' with watercolour and is to be avoided.

Pastels are so similar to watercolour that the effects and techniques for each medium have many parallels, as detailed here.

- Dry brushing – if you lightly drag the side of the pastel stick across the surface of textured watercolour paper, pastel will stick to the raised parts and miss the troughs of the paper's surface. This is equivalent to dry brushing with watercolour and means that some of the underlying colour will peep through. This can be useful for covering and tinting large areas.
- Scumbling – if you adjust the pressure with which you apply the pastel when dry brushing, you will fill more of the paper. You can put layers of different colours over each other, so that the bottom layers peep through. This is referred to as scumbling.
- Blending – if you drag the pastel stick across the paper slightly more heavily and then blend the pastel with either your finger or a paper stump, you will get the equivalent of a soft wash on the paper. You can achieve a graduated wash through heavier application of pastel in certain areas of the paper, and, by laying down two different pastel colours and then blending, you will achieve the same effect as for a colour-graded wash.
- Blending with water – blending pastel with clean water gives a similar effect to that of wet-in-wet watercolour, though the result is less transparent.
- Lifting off – just as it is possible to lift off watercolour paint with a clean damp brush, it is possible to lift off some or most of the pastel by using a tissue, a kneaded eraser or a stiff-bristled brush.

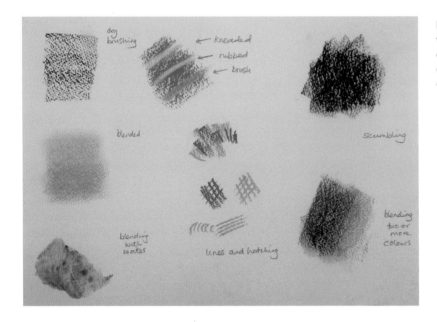

Pastels and watercolours complement each other in how they can be applied.

- Lines and hatching – by using the end of the pastel stick or pencil, you can achieve finer lines and details, which allows more of the surface or support to show through. You can use crosshatching to build denser coverage or texture. Following the contours of the subject with line strokes can be effective, adding the impression of movement and giving form to the subject.

Fixing and storing

Pastel paintings do need to be handled and stored with care, and, while there is no requirement to use a fixative, many artists choose to do so. The downside is that fixatives can lead to a colour shift, so, if you are in doubt about how a fixative will perform, do a test before using it on your artwork.

Fixative is similar to varnish. When sprayed on to your dry artwork, it helps stick the dust of the pigment, charcoal or graphite that you have used to the surface of the paper or support. You may use it at the end, on the finished piece, or at various points as you work, if you do not wish

to disturb the first layers (see 'Scumbling' in the previous section 'Techniques'). If you choose to apply fixative several times during your work on a piece, read the fixative's instructions carefully, making sure that you can apply subsequent layers of both the medium being used and the fixative. Apply the fixative only in a well-ventilated room or preferably outside, as the solvents will certainly not do your lungs any good.

Avoid using hairspray on anything that you wish to preserve. It is unlikely to be acid-free, so it may either degrade your paper or change colour with time. If it is for a practice piece and it's all you have to hand then go ahead, and the cheaper the hairspray the better: more expensive ones may contain conditioners, perfumes and so on, all of which will certainly not be desirable for your poor painting.

If the artwork is to be displayed under glass, you do not need to fix the surface; nevertheless, you will need to mount your work, to ensure that the glass does not rub the pastels, and leave the bottom of the mount free so that dust can fall down behind it rather than gather on its edges. If storing several pieces of artwork together, put an acid-free sheet of paper or tissue between each piece to prevent cross-contamination.

Step by step: barn owl

Having sat and studied a barn owl at a local museum, I was keen to try to paint it.

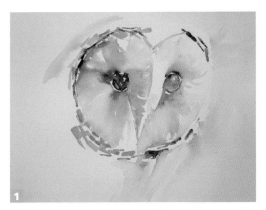

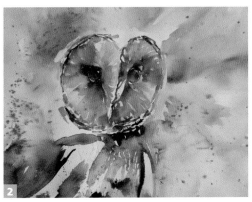

I started by painting this owl from its eyes and working outwards. I made sure that I went a little darker with tone than I might otherwise have done, as I knew I would be adding pastels later on.

Of course, if the painting started to turn out really well, I could have carried on and kept it as a pure watercolour painting. It is worth following the advice of 'if something nice is happening, stop'.

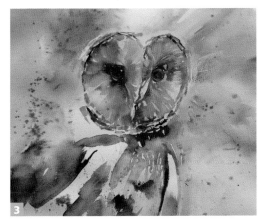

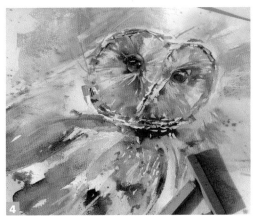

Once the watercolour was dry, I used soft pastels in a range of colours from white through yellows and oranges to cool greeny-blues to build texture and the impression of movement. I started by scumbling with the edge of the pastel and then used the end to add in more linear marks that I felt reflected the feathers.

I continued to build the pastel layer, and, after a period of reflection, I used a pastel pencil to work around the eyes.

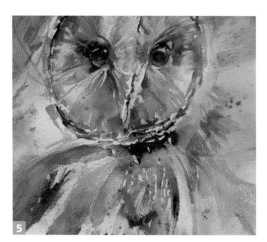

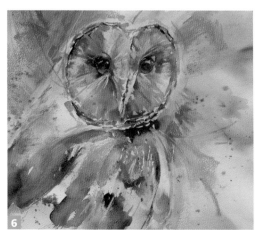

My aim was to make sure that the watercolour and pastel combined so that neither looked like an afterthought.

Once I was happy, I sprayed the piece with a workable fixative. I know that this may darken the pastels, but it was a risk worth taking, given the protection it offers.

Charcoal

Charcoal can be used very successfully over a dried watercolour wash. Drawing, erasing and blending actions with the charcoal are not altered because of the watercolour, provided that the wash is completely dry.

Of course, you may wish to add watercolours over a charcoal drawing. To avoid a muddy mess, use a workable fixative. Some manufacturers suggest using a fixative on the

back of the paper as well. Testing a small area first will allow you to double-check that the charcoal will not move.

Liquid charcoal is a relatively new product made from powdered charcoal and gum arabic, along with other magic ingredients. It is water-soluble and can be used thick, like an oil, or thinned, like watercolour. It granulates beautifully and can be worked once dry in a similar way as for charcoal sticks. You can adjust the values from very light to a deep, rich black.

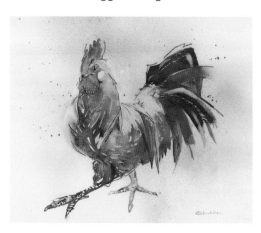

Strutting His Stuff, 37×37cm, watercolour and charcoal on paper.

Liquid charcoal combines the properties of watercolour and charcoal in a fluid paint.

Step by step: lion

This scarred lion seemed an ideal subject for which to attempt a drawing in liquid charcoal.

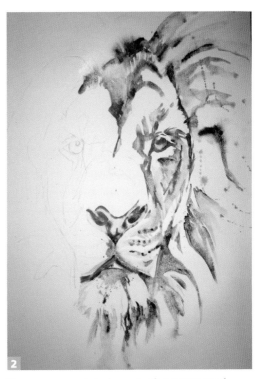

Starting with the charcoal layer, I worked from the eyes out. If you struggle to see tone and are using a photographic reference rather than your own sketches, you can convert your photo to black and white. This will help to train your eye over time to assess tone, so that you will no longer need to use such a greyscale reference. The liquid charcoal granulates beautifully and, even at full strength, is deep grey rather than black. Just as with watercolours, ensure that you vary the tone and have a variety of edges too.

You can appreciate how much water I used from the amount of reflection.

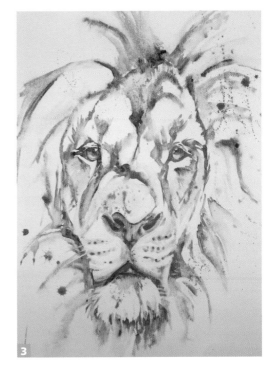

RIGHT: Allow this layer to dry, and adjust any marks or tones by using a kneaded putty eraser. You will find that the full-strength areas are hard to erase, because of the concentration of binder. Where the charcoal was thinned, it will lift completely.

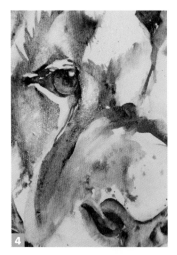

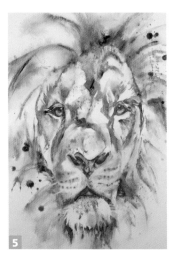

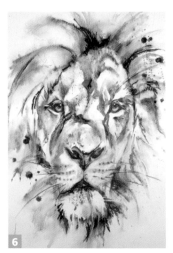

Next, add the watercolour layer. You will need to work with a very soft brush and a very light touch, as otherwise the charcoal will shift. If you struggle to work with a light touch and you want crisp marks of charcoal, consider adding AQUA Fix (Schminke) to the initial wash. AQUA Fix is an additive that makes watercolours waterproof.

The finished watercolour layer needs to dry fully before you go any further.

Once dry, use vine charcoal or, if you prefer, a charcoal pencil, to add areas of deep tone or to crisp up details around the eyes and, of course, add in the all-important whiskers. You need to use a fixative, but make sure to apply it in a well-ventilated area because of its solvent content.

Collage

Collage is a technique where different materials are combined to create a new whole. Anything can be used in collage, but paper is the most frequently used material. The danger to be avoided is that the materials you use may become clichéd and a substitute for the painted form.

While it is probably better to start a painting knowing that it will be collaged, realistically, a failed painting might be rescued or could be ripped or cut and used as collage materials.

Possible approaches to collage

Watercolour and collage is a huge subject; the possible combinations of media and techniques are endless. If this is a technique that appeals to you, you have a lifetime of exploration ahead. Here are some possible applications.

- Using watercolour to colour and pattern papers, which are then torn or cut and put back together to form the image.
- Adding an interesting element of pattern to your work, though creating a background that has a connection to the main painted image. Working on the pages of an old book, maps or a music score may add an extra

dimension to your work, from either the pattern of the print or the connection to the concept you wish to communicate. Selecting a shape or part of the composition to be made of collaged paper can also be effective.

- Bringing a three-dimensional quality to an essentially two-dimensional piece with thicker collage pieces or objects. The challenge is to ensure that whatever is stuck on does not look like an afterthought or later become detached.
- Introducing real texture to highlight particular areas or give an interesting twist to a representation; we are used to creating the illusion of texture with watercolour, but actual texture is achievable with collage and complements the watercolour. For example, painting over a collaged background of tissue paper might evoke the impression of ripples on water.
- Introducing text may reinforce an underlying concept and is a classic use of collage. Perhaps adding Hindi text to a painting of a peacock would help to convey the Indian heritage of the bird. Or, you could paint a sheep on a collage of a farming magazine or paint an endangered animal on articles about global warming.

Materials and techniques

As already mentioned, using paper in collage is my preferred method. There are myriad gorgeous papers available, and you will develop a magpie habit of never throwing out scraps, once you become awake to the possibilities of collage.

Papers

- Tissue paper – look for acid-free paper to avoid it yellowing with time. Coloured tissue papers may well leach their colours when wet and are probably not lightfast, so using white for texture or colouring your own with watercolours may be advisable.
- Japanese and handmade papers – if you are looking for papers with interesting textures and inclusions, there are thousands of oriental papers, particularly Japanese, to choose from, as well as a variety of handmade papers.
- Printed text – pieces of old or foreign newspapers can make for interesting additions to your paintings. These will yellow with age, so you can accept that as part of the artistic process or avoid using them. Be aware with newspapers in languages or scripts that you

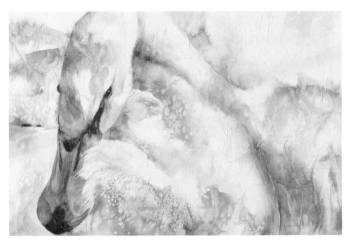

Thames Swan, **60×80cm, watercolour on collaged canvas. I stuck acid-free tissue paper on to the canvas with dilute PVA glue before applying watercolour ground. You can do the same on watercolour paper, in which case you do not need to apply ground.**

do not understand: you may have inadvertently selected an offensive phrase. If possible, get a native speaker to cast an eye over the text before use.

- Patterned papers – with the popularity of scrapbooking, a wonderful range of acid-free preprinted papers are readily and cheaply available. Note that, if you use wrapping paper, it is unlikely to be of archival quality. Consider carefully any copyright implications of the use of preprinted papers. While using them in your artwork will not infringe the original designer's copyright, should you decide to then create prints or greetings cards from your artwork, you may have legal issues. Please investigate copyright issues thoroughly before the use of a particular image, design or pattern, should this be a path you wish to go down.

- Manufactured coloured papers – plain papers, with or without textures, can be used as additions to your paintings. Once again, check whether the colours are waterfast and whether the papers are acid-free. You will find that torn edges are easier to integrate than cut ones, but, of course, if you want to draw attention to an area, a cut edge will work.

- Watercolour paper – pieces of plain watercolour paper that are applied in different areas of a painting might be all the addition that you need.

- Failed watercolour paintings – a painting may be beyond redemption, but small areas of it may have interesting marks or colour combinations. Ripped up or cut to shape, these failed paintings will have a second life in your collages.

- Wallpapers – These can provide very interesting textures. Some Anaglypta-type paper is paintable, but you will need to check its compatibility with watercolours, and any other medium that you wish to use, and may need to first coat the paper's surface with watercolour ground.

Glue

While the glue needs to be strong enough to bind the surfaces of the materials being used, you do not want it to add bulk and weight. Watered-down PVA is usually strong enough to stick most papers. It will appear white when wet but dry clear and colourless. There are water-soluble PVA glues, so check the qualities of the glue you intend to use before starting your painting, so that your creation does not fall to pieces if you later use multiple washes over your collage.

As a rule of thumb, apply glue to the heaviest paper being used; this will help to protect thin, delicate papers from damage while being applied.

Remember: do not use your watercolour brushes with glue. You will regret it.

Watercolour ground

Certain paper surfaces may repel your watercolours. Inks and acrylics will adhere better than watercolour to shiny or resistant papers.

Rather than struggle with repellent surfaces, an alternative would be to use a transparent watercolour ground to coat the paper's surface and allow easier application of watercolour. This will allow the colour or pattern to remain visible but for the watercolour to flow seamlessly over the surface. Watercolour ground will also fill in gaps and unify the surface. One layer of watercolour ground is not fully opaque. A layer of white watercolour ground can be useful to knock back an overly dominant pattern or can be applied in a specific area rather than over the entire surface of the artwork.

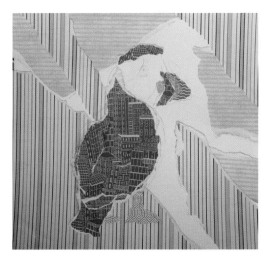

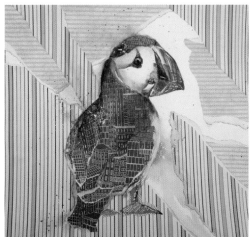

Select papers that will help to communicate what you want to say. I found some cityscape paper, which I tore into shape to form the body. Tearing gives a less intrusive edge, so always consider whether you want to tear or cut your shapes to achieve the desired effect. Depending on whether you tear from the front or the back, you will get either a white edge on a printed sheet or not. I thought here that the white edge added definition. The background papers reminded me of sea and cliffs. Once you are happy with your paper selection and shapes, stick them to your watercolour paper with diluted PVA glue. Try to ensure that no glue gets on to the top layer or any remaining exposed watercolour paper. If you need further support, you can start by adhering the watercolour paper to something like a piece of mount board, to prevent buckling. While the PVA dries, cover the prepared support with a waxed non-stick paper – the inside of a cereal packet serves well – and weigh down the support until it is flat and completely dry.

Examples: puffin and toucan collages

I used collage on this small rendition of a puffin, or sea parrot, whose population is in sharp decline. Puffins are listed with a conservation status of 'vulnerable'; pollution, overfishing and climate change are all cited as reasons for this decline.

Now, sketch in any features and proceed to paint in the normal manner. You will find that the watercolour does not flow well on the slick surface of the collage paper. If this is an issue, you can apply a coating of transparent watercolour ground; for this piece, I just lived with it. If the water of your washes lifts any collage-paper edges, apply a little more glue beneath them and again allow the paper to dry flat. If the piece is to be framed, it needs no finishing.

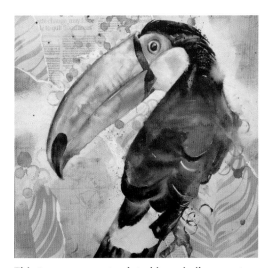

This toucan was completed in a similar way to the puffin, by using newspaper articles about the environment and printed papers. Because the patterns were very dominant, I used one coat of a white watercolour ground that is not fully opaque, to knock back those designs and allow the watercolour to flow.

Exploiting texture through collage

Watercolour is a flat medium, but, as mentioned earlier, sometimes you might want to add a little texture.

Step by step: Romeo ram

A Swaledale ram offered the opportunity of exploring the use of all sorts of different textures.

I chose a number of Anaglypta wallpapers to represent the different textures and tore or cut them to shape. The cut edges worked well for the horns, with softer torn shapes for the woollier parts. Once happy with the arrangement, I stuck all of the elements onto a backing board using strong PVA glue, paying special attention to the edges. As I knew I would be coating the collage layer with watercolour ground, there wasn't an issue if any glue got on to the surface.

Once the glue was dry, I applied three thin layers of watercolour ground. I worked it in well to all the textures and torn edges. It covered the different colours of the original wallpaper and unified the entire surface preparing it to be painted.

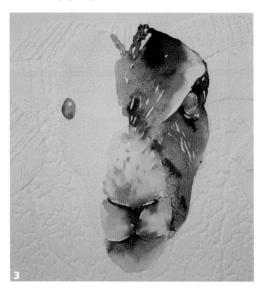

LEFT: Once the watercolour ground was dry (twenty-four to forty-eight hours later), it was time to start to paint. I started with the eye and worked outwards in the normal way. The temptation is to change your painting technique when faced with a novel situation, but everything we have practised still holds true.

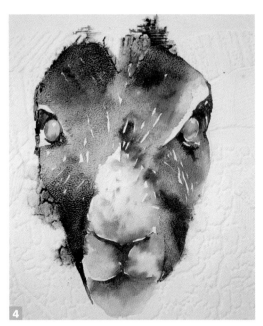

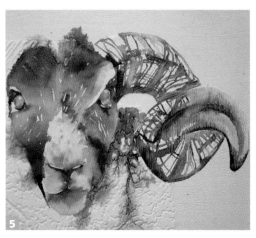

5

I made sure that the horns had very different marks to those of the woolly head and body.

4

While being mindful of all the lovely texture present, I still took care to let the colour flow and to introduce plenty of variety into my mark-making.

BELOW: Once completed, a few coats of matt varnish were used to seal the end result. My plan is to put this piece on to a cradled board, so that it can be displayed without glass to ensure the textured surface can be readily seen.

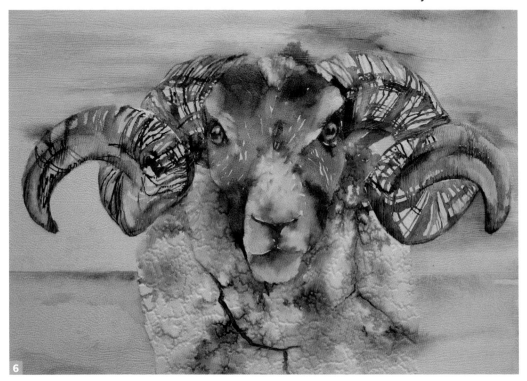

6

USEFUL RESOURCES

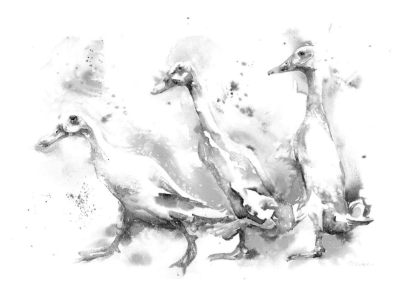

Ready, Steady, Go, 35×45cm, watercolour on paper.

Bibliography and further reading

Chaderton, L., *Painting Watercolours on Canvas* (The Crowood Press, 2019)

Garner, J., *The Wildlife Artist's Handbook* (The Crowood Press, 2013)

Johnson, C., *Artist's Sketchbook: Exercises and techniques for sketching on the spot* (North Light Books, 2016)

Masters, C., *Bestiary Animals in Art from the Ice Age to Our Age* (Thames & Hudson, 2018)

Pond, T., *The Field Guide to Drawing and Sketching Animals* (Search Press, 2019)

Rossi Armfield, G., *No Excuses Art Journaling: Making time for creativity* (North Light Books, 2013)

Useful websites

By the author

lizchaderton.co.uk/

Nature journaling

www.johnmuirlaws.com

Royalty-free photographs

pmp-art.com
stocksnap.io
unsplash.com
pixabay.com

INDEX